MARY FORD

Writing in Icing

With easy to follow instructions

AUTHOR

Mary Ford has been teaching the art of cake decorating for three decades. Working with her husband, Michael, she has produced over twenty step-by-step books demonstrating the various skills and techniques of the craft. Her books have gained a worldwide reputation for expertise and imagination, combined with common sense and practical teaching ability. Her unique step-by-step approach with the emphasis on self-explanatory colour illustrations is ideally suited for both beginners and enthusiasts.

PREFACE

Following many requests over the years from friends and customers to produce a book on "Writing in Icing", Mary Ford has succumbed and accepted the challenge. This book is intended for the amateur cake maker and decorator as well as the experienced practitioner and uses styles that have been created and tested by Mary. With the established step-by-step teaching system, this book is the next best thing to having Mary standing alongside you in the kitchen!

First Published 1987
This edition Published 1996

ISBN: 0 946429 57 X

FOREWORD

A beautifully decorated cake can be so much more then just the centrepiece of a tea table. It can be a very special way of saying "Happy Birthday", "Good Luck", "Happy Anniversary", "Congratulations" or one of hundreds of different and personal messages of love and friendship. The finishing touch to such a cake is the writing of the words themselves, whatever they may be saying, and how often those words or numbers let us down, and by being written in an obviously amateur way wreck all the hard work that has gone before. I have often tried to avoid the issue by leaving out the vital message because I knew it would not be up to standard.

Now, thank goodness, Mary has come to our rescue! I have been a devotee of Mary Ford for many years. Then she and her husband Michael started to produce the wonderfully clear and helpful books about decorating that have been such an inspiration to all of us. All that was needed was some help with that tricky business of Writing!

And here at last it is. With this brilliant book Mary has saved us from those wobbly messages sloping their way across our creative efforts, and has shown us how to give our cakes that very special professional finish. No longer will our cakes be silent... now they can talk!

CONTENTS

MARY FORD TITLES

101 Cake Designs
ISBN: 0 946429 00 6 320 pages
The original Mary Ford cake artistry text book. A classic in its field, over 200,000 copies sold.

Cake Making and Decorating
ISBN: 0 946429 41 3 96 pages
Mary Ford divulges all the skills and techniques cake decorators need to make and decorate a variety of cakes in every medium.

Jams, Chutneys and Pickles
ISBN: 0 946429 48 0 96 pages
Over 70 of Mary Ford's favourite recipes for delicious jams, jellies, pickles and chutneys with hints and tips for perfect results.

Kid's Cakes
ISBN: 0 946429 53 7 96 pages
33 exciting new Mary Ford designs and templates for children's cakes in a wide range of mediums.

Children's Birthday Cakes
ISBN: 0 946429 46 4 112 pages
The book to have next to you in the kitchen! Over forty new cake ideas for children's cakes with an introduction on cake making and baking to ensure the cake is both delicious as well as admired.

Party Cakes
ISBN: 0 946429 13 8 120 pages
36 superb party time sponge cake designs and templates for tots to teenagers. An invaluable prop for the party cake decorator.

Quick and Easy Cakes
ISBN: 0 946429 42 1 208 pages
The book for the busy mum. 99 new ideas for party and special occasion cakes.

Decorative Sugar Flowers for Cakes
ISBN: 0 946429 51 0 120 pages
33 of the highest quality handcrafted sugar flowers with cutter shapes, background information and appropriate uses.

Cake Recipes
ISBN: 0 946429 43 X 96 pages
Contains 60 of Mary's favourite cake recipes ranging from fruit cake to cinnamon crumble cake.

One Hundred Easy Cake Designs
ISBN: 0 946429 47 2 208 pages
Mary Ford has originated 100 cakes all of which have been selected for ease and speed of making. The ideal book for the busy parent or friend looking for inspiration for a special occasion cake.

Wedding Cakes
ISBN: 0 946429 39 1 96 pages
For most cake decorators, the wedding cake is the most complicated item they will produce. This book gives a full step-by-step description of the techniques required and includes over 20 new cake designs.

Home Baking with Chocolate
ISBN: 0 946429 54 5 96 pages
Over 60 tried and tested recipes for cakes, gateaux, biscuits, confectionery and desserts. The ideal book for busy mothers.

Making Cakes for Money
ISBN: 0 946429 44 8 120 pages
The complete guide to making and costing cakes for sale at stalls or to friends. Invaluable advice on costing ingredients and time accurately.

Biscuit Recipes
ISBN: 0 946429 50 2 96 pages
Nearly 100 biscuit and traybake recipes chosen for their variety and ease of making. Full introduction for beginners.

The New Book of Cake Decorating
ISBN: 0 9462429 45 6 224 pages
The most comprehensive title in the Mary Ford list. It includes over 100 new cake designs and full descriptions of all the latest techniques.

A to Z of Cake Decorating
ISBN: 0 946429 52 9 208 pages
New dictionary style home cake decorating book with step-by-step examples covering techniques and skills of the craft. Suitable for the beginner and enthusiast alike.

Novelty Cakes 120 pages
ISBN: 0 946429 56 1
Over 40 creative ideas to make a successful party. Introduction and basic recipes for beginners with a full step-by-step guide to each cake design.

BOOKS BY MAIL ORDER

Mary Ford operates a mail order service for all her step-by-step titles. If you write to Mary at the address below she will provide you with a price list and details. In addition, all names on the list receive information on new books and special offers. Mary is delighted, if required, to write a personal message in any book purchased by mail order.

Write to: Mary Ford,
 30 Duncliff Road,
 Southbourne, Bournemouth,
 Dorset. BH6 4LJ. U.K.

Royal Icing Recipe

Metric/Imperial

42 g/1½ ozs powdered egg white
284 ml/½ pint cold water
1½ kg/3½ lb best icing sugar, sieved

OR

14 g/½ oz powdered egg white
3 fluid ozs/ 3 tablespoons cold water
454 g/1 lb best icing sugar, sieved

OR

3 fresh egg whites (separated the day before)
454 g/1 lb best icing sugar (approximately) sieved

American

¼ cup powdered egg white + 2 tablespoons
1¼ cups cold water
3½ cups confectioner's sugar, sifted

OR

¼ cup powdered egg white
3 tablespoons cold water
3½ cups confectioner's sugar, sifted

OR

3 egg whites (separated the day before)
3½ cups confectioner's sugar (approximately) sifted

Preparation for making egg white solution

All equipment used must be perfectly cleaned and sterilised. Pour water into a jug and stir in powdered egg white. This will go lumpy and necessitates standing the mixture for one hour, stirring occasionally. Then strain through a muslin.

Method

Pour egg white solution or fresh egg whites into a mixing bowl and place the icing sugar on top. A drop of blue colour (color) may be added for white icing. Beat on slow speed for approximately 15-20 minutes or until the right consistency is obtained. (If powdered egg white is used the Royal Icing will keep in good condition for 2 weeks. Fresh egg whites will deteriorate quicker). Store Royal Icing in sealed container in a cool place.

Basic Instructions

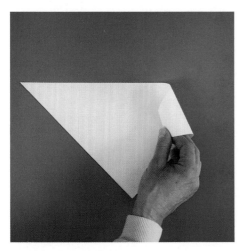

MAKING A PIPING BAG
1. A sheet of greaseproof paper – 12″×8″ required.

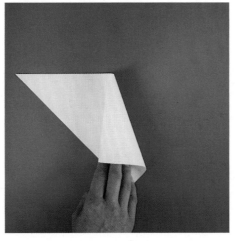

2. Cut sheet diagonally as shown.

3. Turn one triangle to position shown.

4. Using right-hand, curl the right corner of paper towards centre.

5. Continue curling paper, as shown.

6. Using left hand, bring left-hand corner of paper over to the right.

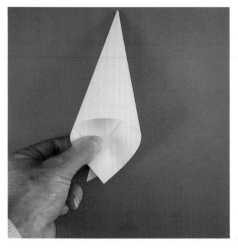

7. Continue by curling paper under the cone.

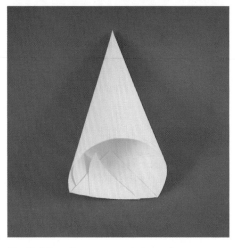

8. Fold and crease ends into the cone.

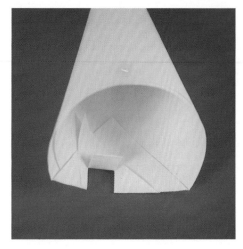

9. Make two cuts and fold paper inwards to secure piping bag.

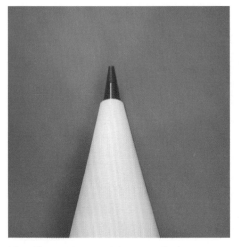

10. Cut off tip of bag and drop in a piping tube.

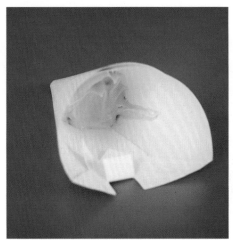

FILLING A PIPING BAG
11. Using a palette knife, half fill bag with royal icing.

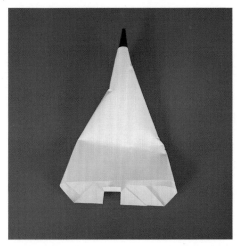

12. Flatten the wide opening of the bag, gently squeezing the icing towards the tube.

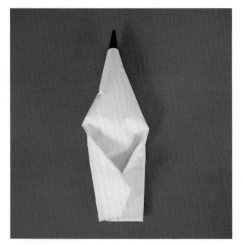

13. Fold each side of the bag to the centre.

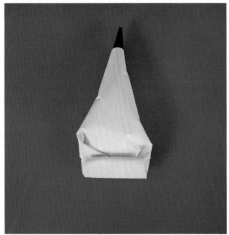

14. Roll the wide end of the bag towards the tube, to seal the bag.

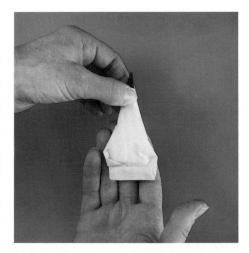

HOW TO HOLD A PIPING BAG
15. Place the piping bag onto the tips of your fingers.

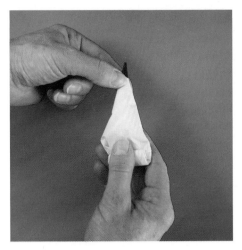

16. Now place thumb against the rolled end.

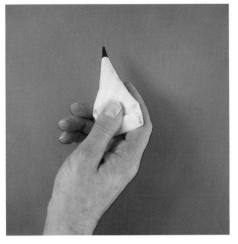

17. Prepare to use bag for piping.

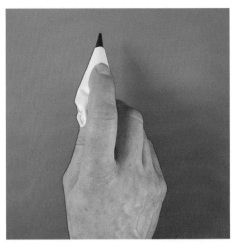

18. Turn hand over so that the first finger is in line with the icing tube.

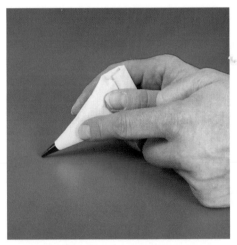

HOW TO PIPE A STRAIGHT LINE
19. To steady the tube, use both hands. Touch surface with tube end, keeping bag at the angle shown.

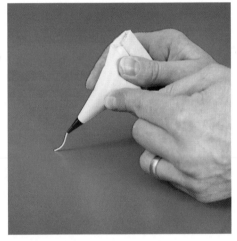

20. Squeeze bag until icing appears, then pipe and, at the same time, lift bag.

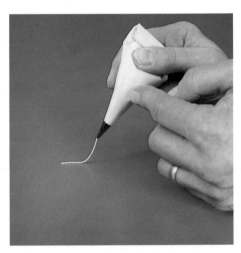

21. Continue piping whilst keeping bag at the height shown and bringing it towards you.

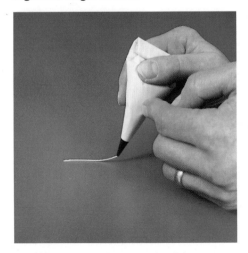

22. Before reaching end of line, stop squeezing and start to lower the bag to the surface — whilst keeping the icing line taut.

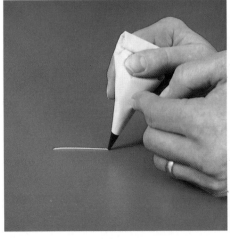

23. Continue to lower bag whilst bringing it into a more vertical position.

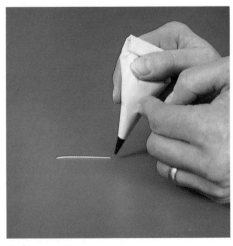

24. To finish line, touch the surface with the tube and pull the tube away whilst keeping the bag upright.

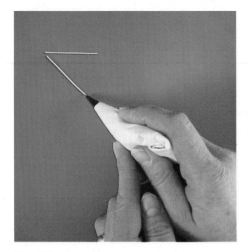

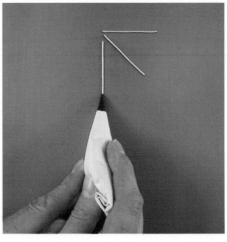

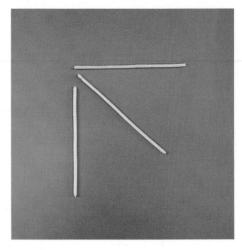

25. When piping a straight line always bring tube towards you.

26. When piping a straight line always bring tube towards you.

27. Picture showing straight lines at various angles.

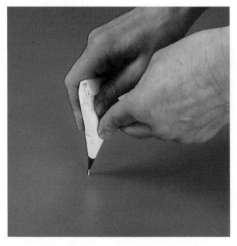

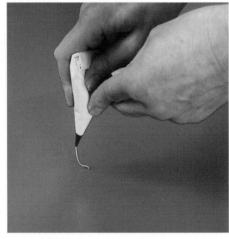

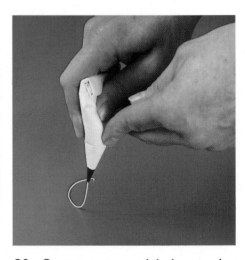

HOW TO PIPE A CURVED LINE
28. Touch surface with tube in vertical position.

29. Squeeze bag until icing appears, then pipe and, at the same time, lift bag.

30. Continue piping whilst keeping bag at the height shown and start to curve the line.

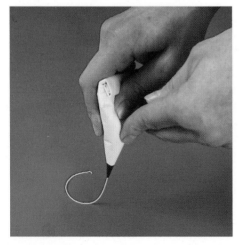

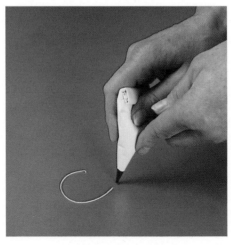

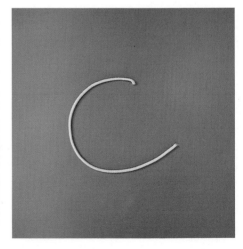

31. Before completing the curved line, stop squeezing and start to lower bag whilst continuing the curve.

32. Complete the curved line by lowering the tube to the surface.

33. Picture showing completed curved line.

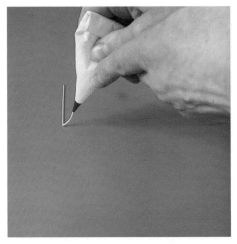

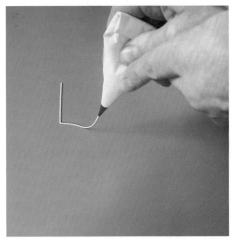

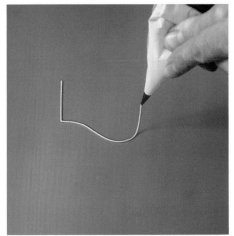

PIPING VARIOUS CURVED LINES
34. Start to pipe at the base of the straight line and then lift bag to the height shown.

35. Continue piping at the same height whilst curving the line, as shown.

36. Gradually lower the tube to create a tighter curve.

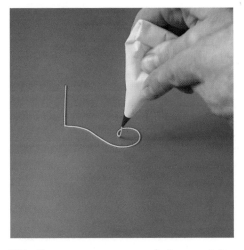

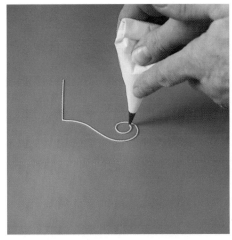

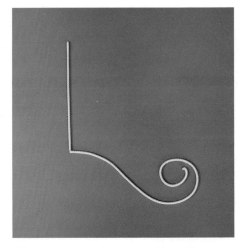

37. Stop squeezing and lower tube whilst continuing curve.

38. To complete the curved line, touch the surface with the tube and then pull tube away.

39. Picture showing completed lines.

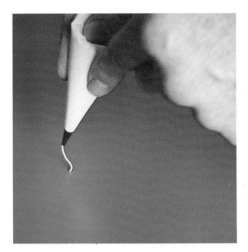

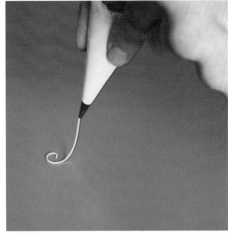

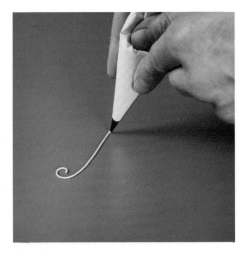

40. Touch tube to surface, squeeze and immediately lift bag vertically to height shown.

41. Move bag in a tight circle whilst continuing piping at the height shown.

42. Stop squeezing and lower tube to surface whilst keeping the icing taut.

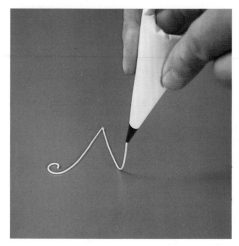

43. Start to pipe at the top and then lift bag to the height shown whilst curving the line.

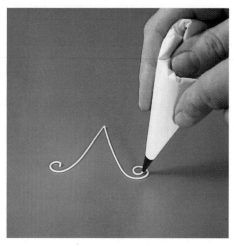

44. Continue piping whilst reducing height. Stop squeezing bag and touch surface with tube to complete the curved line.

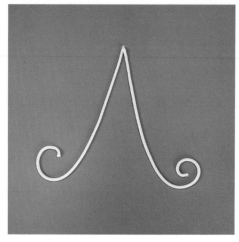

45. Picture showing joined curved lines.

PIPING A ROPE AT THE BASE OF A LINE
46. Pipe a straight line (See No's. 19-24) but do not remove the tube.

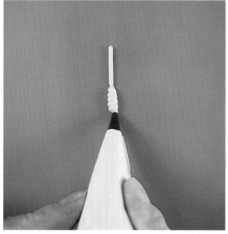

47. Rotate bag in a clock-wise movement, touching the surface on each turn.

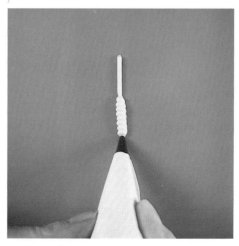

48. Continue as in No. 47 at an even thickness. Stop squeezing and pull tube away at required length.

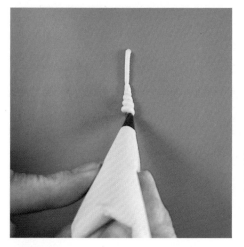

PIPING A BARREL IN A LINE
49. Pipe as in No's. 46-47 but gradually increase the size of the circles.

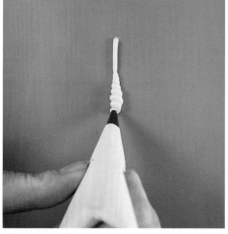

50. At the centre of the barrel gradually decrease circles (so they balance with the first half).

51. Finish by piping a matching straight line. Stop squeezing and pull tube away.

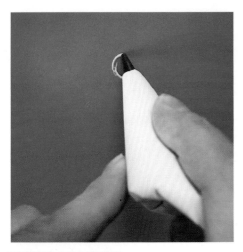

PIPING TRACERY

52. Lightly squeeze bag whilst moving the tube on the surface in the direction shown.

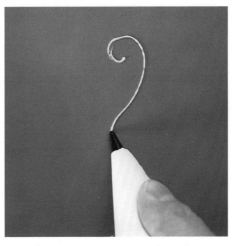

53. Continue piping in the direction shown.

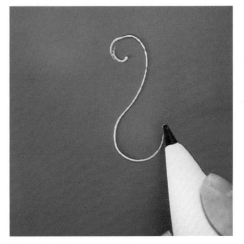

54. Continue piping but stop squeezing bag just before completing the line.

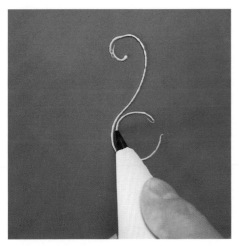

55. Re-start tracery in clockwise direction.

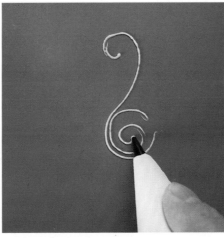

56. Continue spiral line to centre. Stop squeezing the bag and pull tube away.

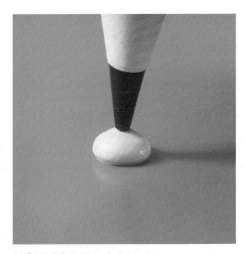

HOW TO PIPE A BULB

57. Hold bag vertically and pipe a bulb, as shown.

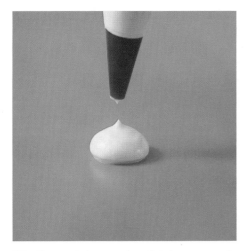

58. Stop piping and pull tube upwards to complete the bulb.

HOW TO PIPE A SHELL

59. Pipe shell whilst holding piping bag at right angles to surface.

60. Stop piping and drop tube to surface, then pull away.

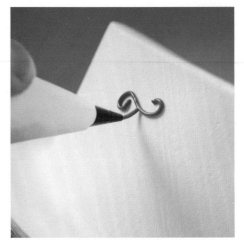

PIPING ON SIDE OF CAKE
61. Tilt cake on a heavy support.

62. Pipe the top of the "J" keeping the tube close to the surface.

63. Touch top of "J" with tube, squeeze bag and pull tube away from surface.

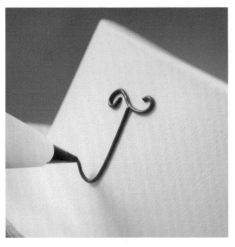

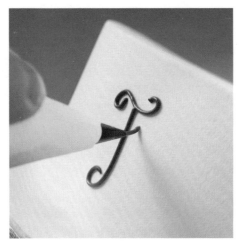

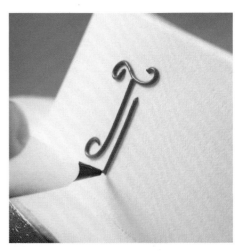

64. Curve bottom of "J" upwards by closing in to the cake's surface.

65. Touch surface with tube, squeeze bag and pull tube away to start the "M".

66. Stop piping and close in to the cake's surface.

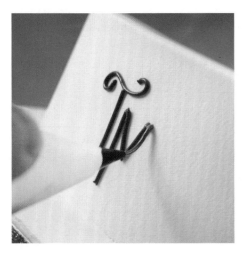

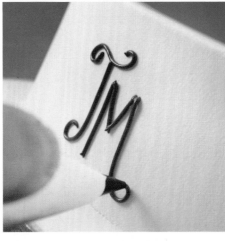

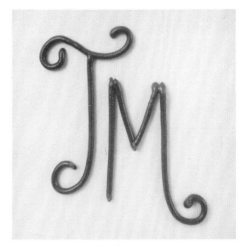

67. Continue piping the "M", as in No's. 65-66.

68. Curve bottom of "M" upwards by closing in to the cake's surface.

69. Picture showing completed "J" and "M".

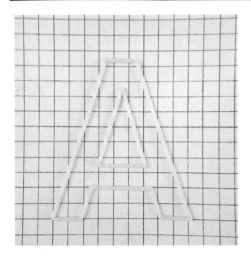

MAKING A RUNOUT

70. Draw a letter "A" (or figure/letter required), then cover with waxed paper and pipe outline.

71. Soften royal icing with cold water and flood-in, as shown.

72. Complete the letter and leave to dry in warm place for 24 hours.

USING GUIDE STRIPS FOR WRITING ON CAKES

73. Cut strips (¼ inch wide) of card.

74. Cut strips to length required and place on cake-top, as shown.

75. Pipe inscription on cake, using same colour icing as cake top.

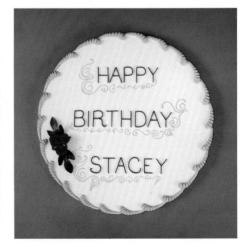

76. Overpipe inscription in colour required.

77. Remove guide strips and decorate with tracery.

78. Complete cake with border and flowers, as shown.

79. Picture showing rearranged guide strips.

80. Picture showing rearranged guide strips.

81. Picture showing rearranged guide strips.

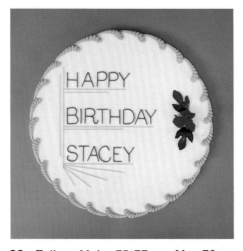

82. Follow No's. 75-77 on No. 79 to complete cake-top shown.

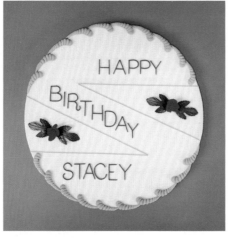

83. Follow No's. 75-77 on No. 80 to complete cake-top shown.

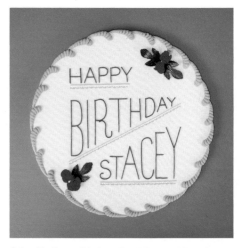

84. Follow No's. 75-77 on No. 81 to complete cake-top shown.

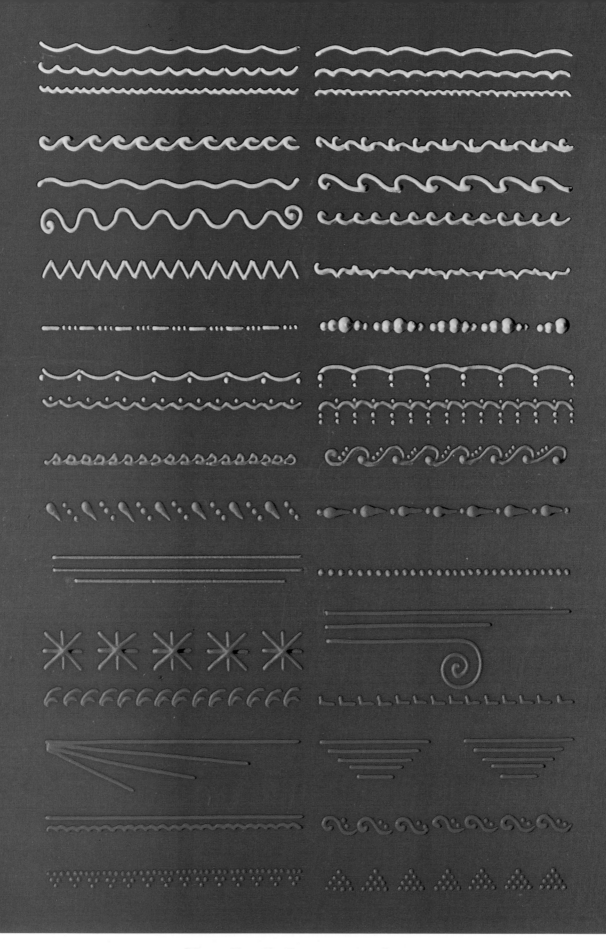

Mary Ford's Decorative Lines

NOTE: Before piping the artwork on this page, please study the basic instructions on pages 5 – 14 and ensure that you have the proper equipment and materials, as well as sufficient time. Additional information can be found on page 96.

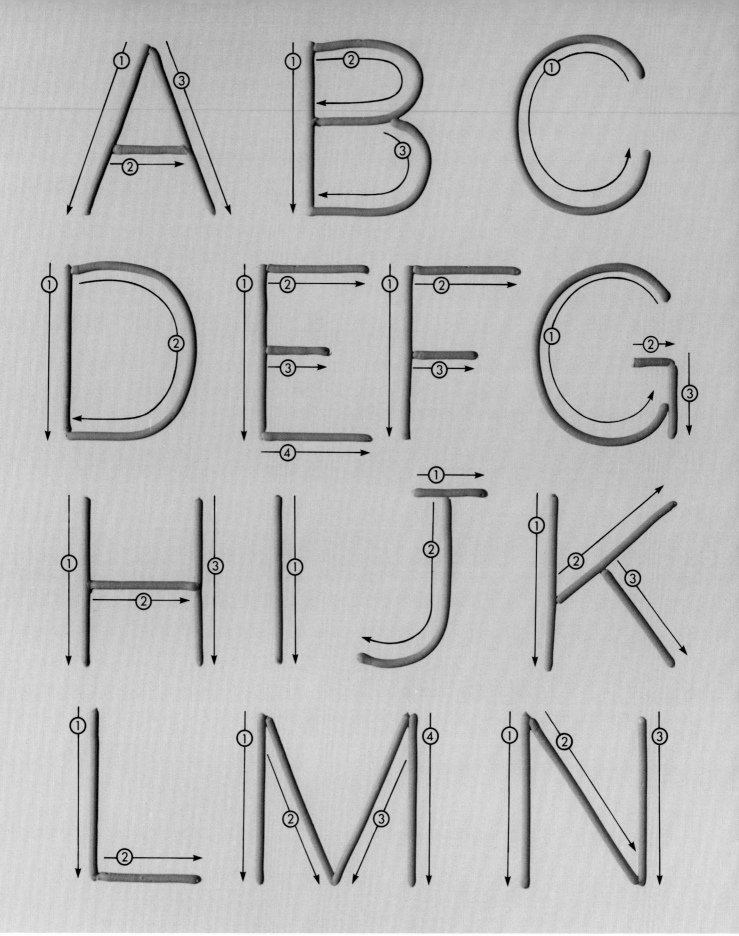

Mary Ford's Writing Style No. 1

Pipe in the direction of the arrow in the sequence shown.

NOTE: Before piping the artwork on this page, please study the basic instructions on pages 5 – 14 and ensure that you have the proper equipment and materials, as well as sufficient time. Additional information can be found on page 96.

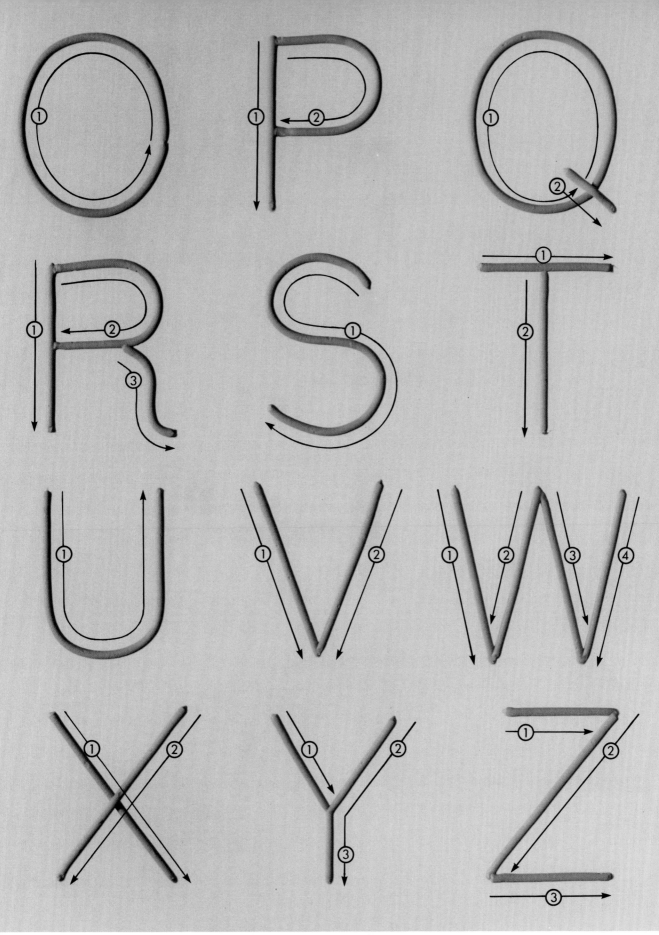

Mary Ford's Writing Style No. 1

Pipe in the direction of the arrow in the sequence shown.

NOTE: Before piping the artwork on this page, please study the basic instructions on pages 5 – 14 and ensure that you have the proper equipment and materials, as well as sufficient time. Additional information can be found on page 96.

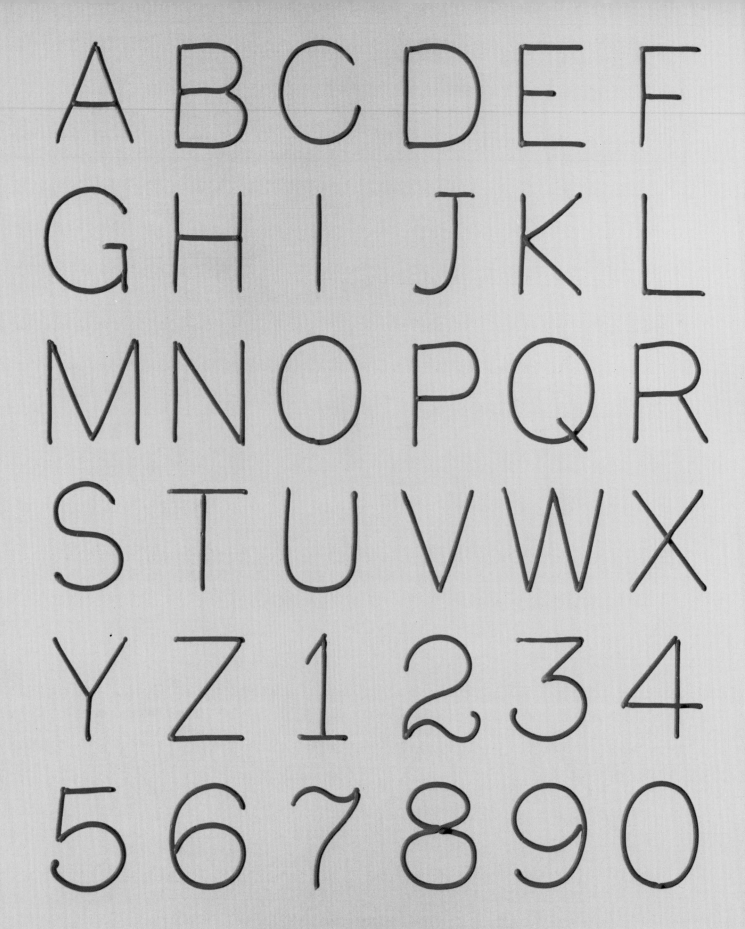

Mary Ford's Writing Style No. 2

NOTE: Before piping the artwork on this page, please study the basic instructions on pages 5 – 14 and ensure that you have the proper equipment and materials, as well as sufficient time. Additional information can be found on page 96.

abcdef
ghijkl
mnopqr
stuvwx
yz123 4
567890

Mary Ford's Writing Style No. 3

NOTE: Before piping the artwork on this page, please study the basic instructions on pages 5 – 14 and ensure
that you have the proper equipment and materials, as well as sufficient time.
Additional information can be found on page 96.

19

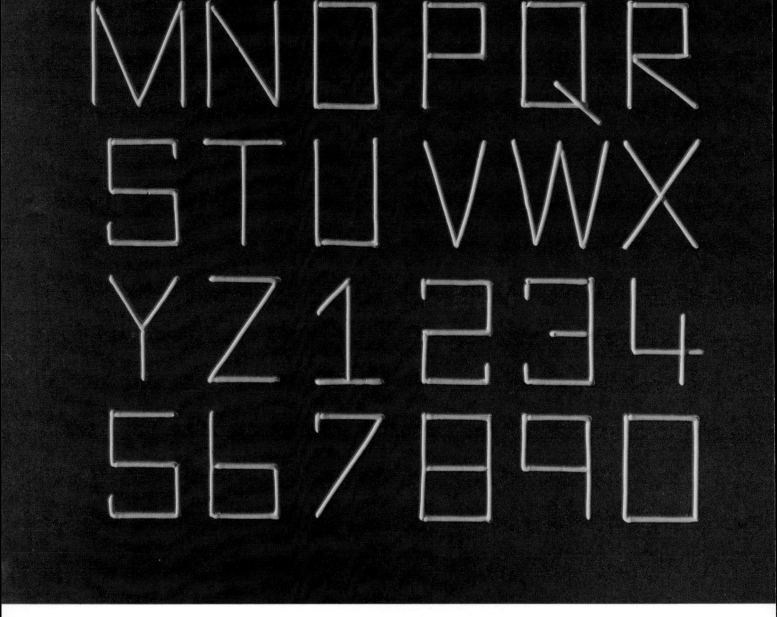

Mary Ford's Writing Style No. 4

NOTE: Before piping the artwork on this page, please study the basic instructions on pages 5 – 14 and ensure that you have the proper equipment and materials, as well as sufficient time. Additional information can be found on page 96.

ABCDEFGH
IJKLMNOP
QRSTUVW
XYZabcdefg
hijklmnopq
rstuvwxyz
1234567890

Mary Ford's Writing Style No. 5

NOTE: Before piping the artwork on this page, please study the basic instructions on pages 5 – 14 and ensure that you have the proper equipment and materials, as well as sufficient time.
Additional information can be found on page 96.

A B C D E F G

H I J K L M N

O P Q R S T

U V W X Y Z

a b c d e f g h i j k l m

n o p q r s t u v w x y z

Mary Ford's Writing Style No. 6

NOTE: Before piping the artwork on this page, please study the basic instructions on pages 5 – 14 and ensure that you have the proper equipment and materials, as well as sufficient time.
Additional information can be found on page 96.

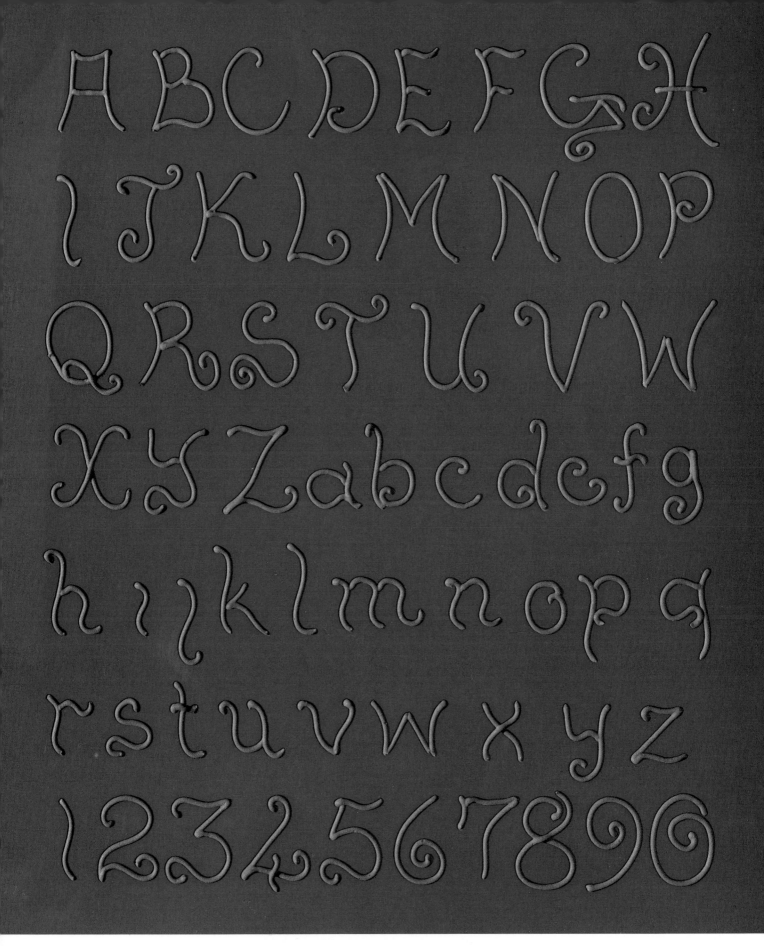

Mary Ford's Writing Style No. 7

NOTE: Before piping the artwork on this page, please study the basic instructions on pages 5 – 14 and ensure that you have the proper equipment and materials, as well as sufficient time. Additional information can be found on page 96.

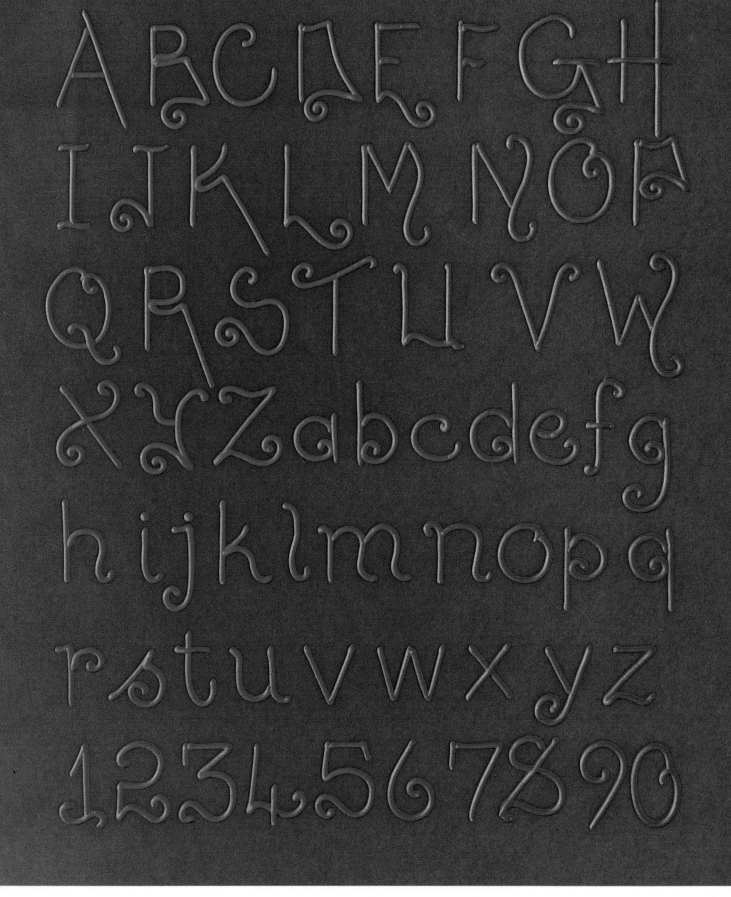

Mary Ford's Writing Style No. 8

NOTE: Before piping the artwork on this page, please study the basic instructions on pages 5 – 14 and ensure that you have the proper equipment and materials, as well as sufficient time.
Additional information can be found on page 96.

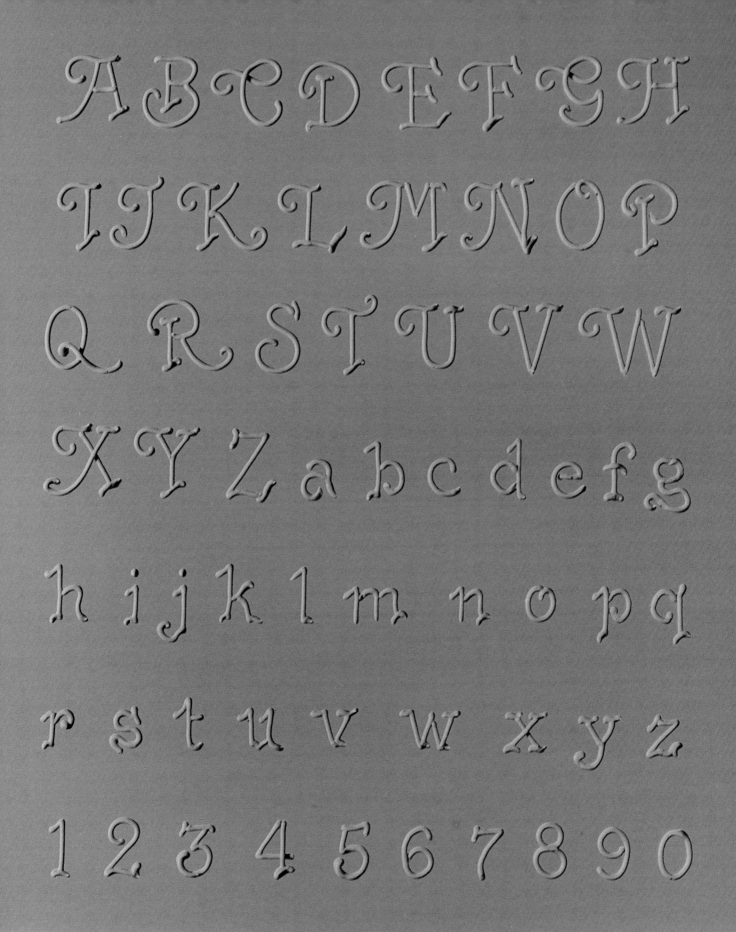

Mary Ford's Writing Style No. 9

NOTE: Before piping the artwork on this page, please study the basic instructions on pages 5 – 14 and ensure that you have the proper equipment and materials, as well as sufficient time. Additional information can be found on page 96.

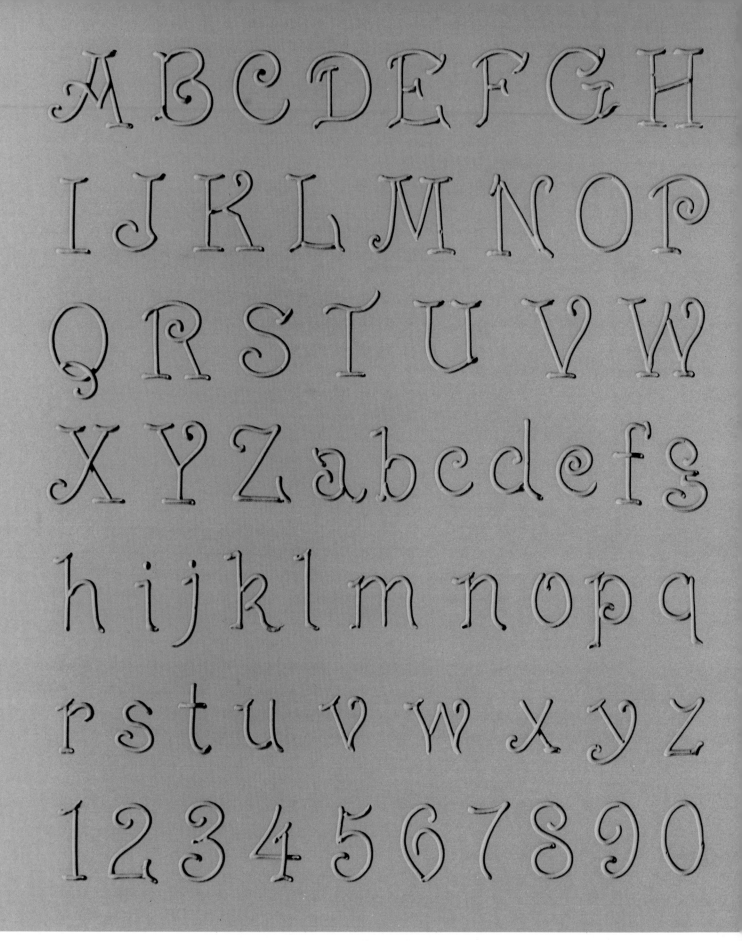

Mary Ford's Writing Style No. 10

Mary Ford's Writing Style No. 11

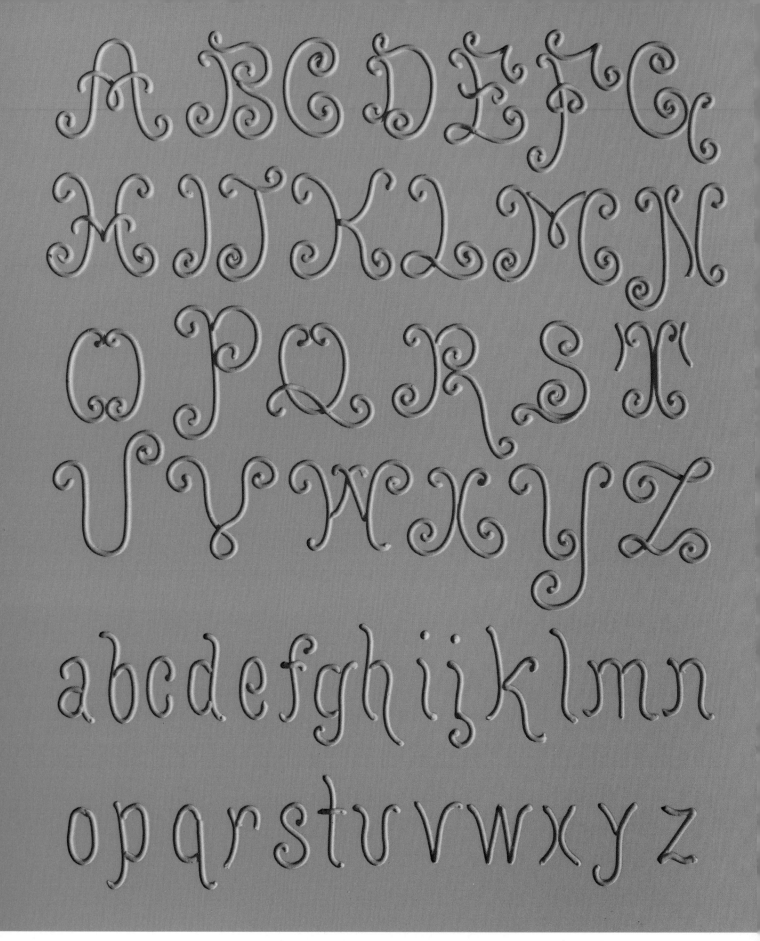

Mary Ford's Writing Style No. 12

ABCDEFG
HIJKLMNO
PQRSTUVW
XYZabcdefg
hijklmnopq
rstuvwxyz
1234567890

Mary Ford's Writing Style No. 13

NOTE: Before piping the artwork on this page, please study the basic instructions on pages 5 – 14 and ensure that you have the proper equipment and materials, as well as sufficient time. Additional information can be found on page 96.

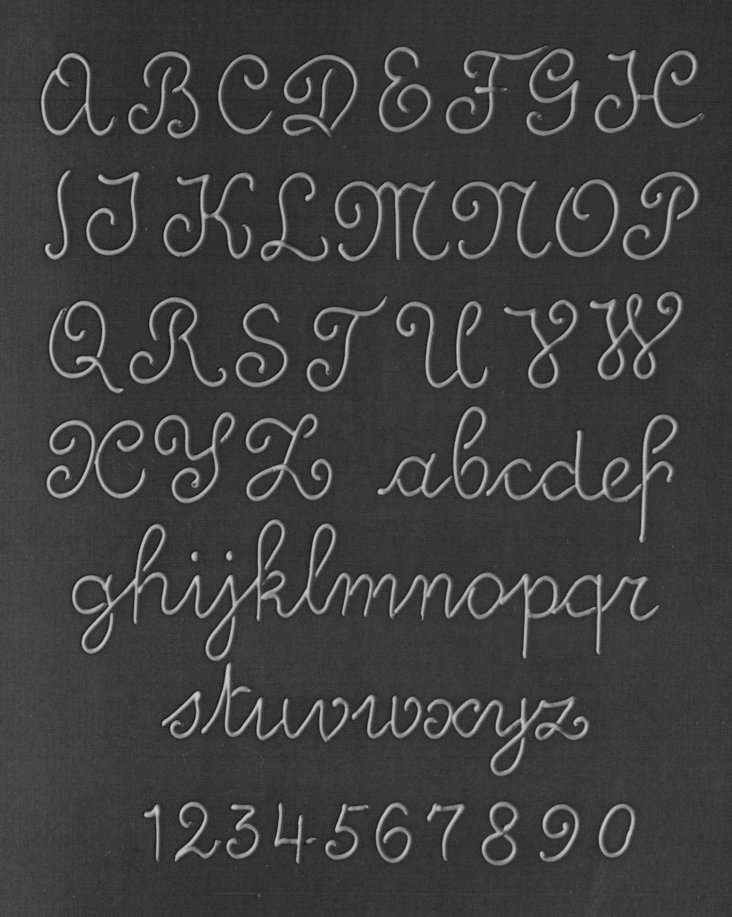

Mary Ford's Writing Style No. 14

NOTE: Before piping the artwork on this page, please study the basic instructions on pages 5 – 14 and ensure that you have the proper equipment and materials, as well as sufficient time.
Additional information can be found on page 96.

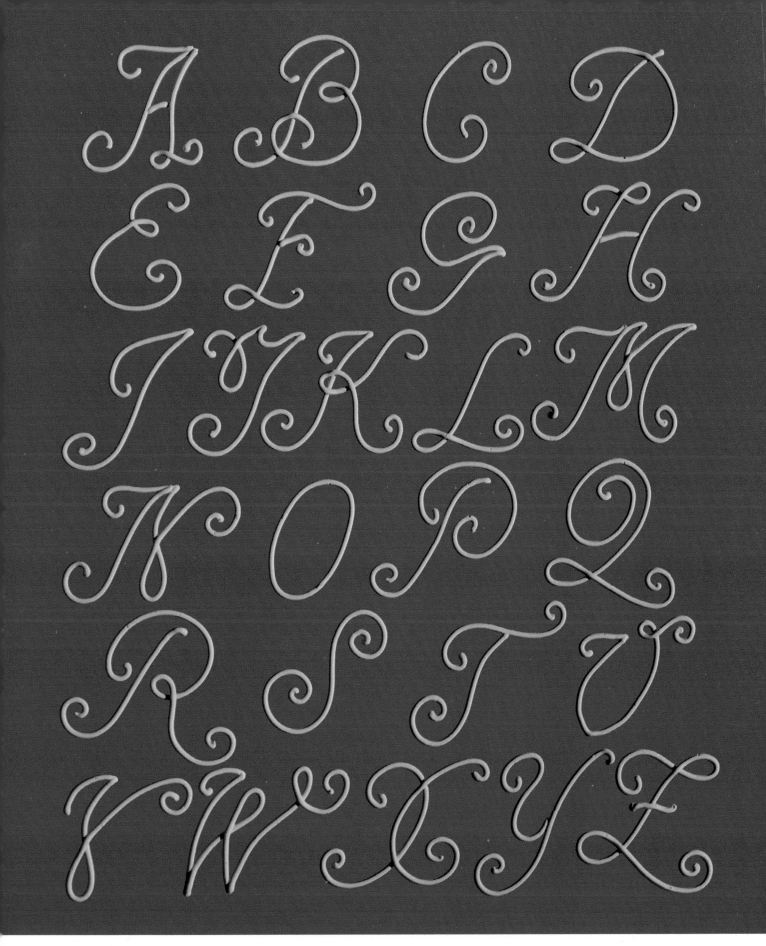

Mary Ford's Writing Style No. 15

NOTE: *Before piping the artwork on this page, please study the basic instructions on pages 5 – 14 and ensure that you have the proper equipment and materials, as well as sufficient time. Additional information can be found on page 96.*

31

Mary Ford's Writing Style No. 16

NOTE: Before piping the artwork on this page, please study the basic instructions on pages 5 – 14 and ensure that you have the proper equipment and materials, as well as sufficient time. Additional information can be found on page 96.

Mary Ford's Writing Style No. 16

A B C D E F G
H I J K L M N
O P Q R S T
U V W X Y Z

a b c d e f g h i j k l m
n o p q r s t u v w x y z
1 2 3 4 5 6 7 8 9 0

Mary Ford's Writing Style No. 17

NOTE: Before piping the artwork on this page, please study the basic instructions on pages 5 − 14 and ensure that you have the proper equipment and materials, as well as sufficient time.
Additional information can be found on page 96.

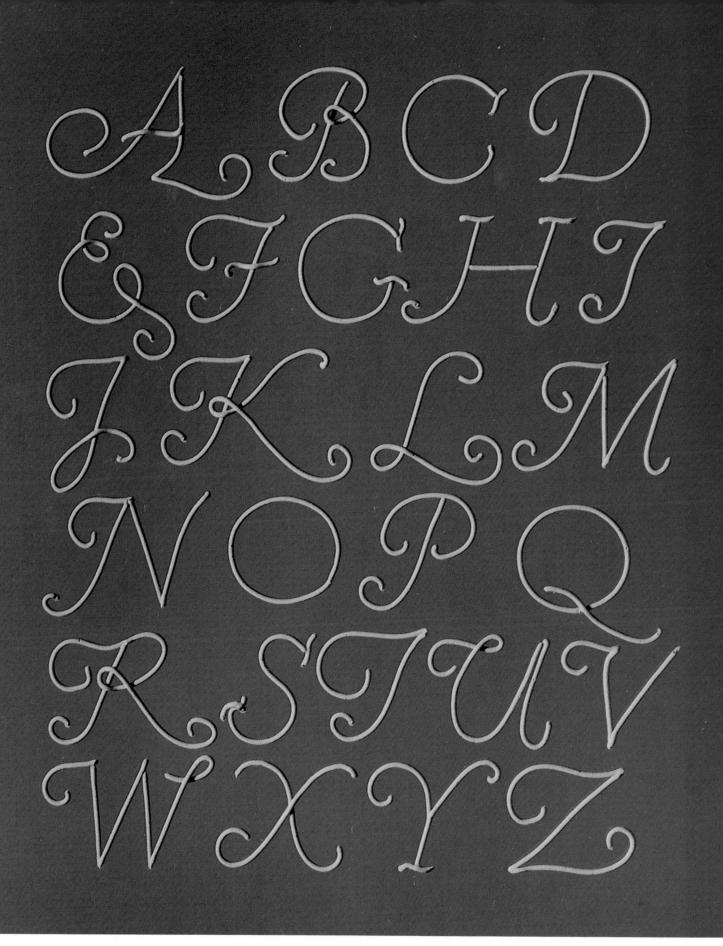

Mary Ford's Writing Style No. 18

NOTE: Before piping the artwork on this page, please study the basic instructions on pages 5 – 14 and ensure that you have the proper equipment and materials, as well as sufficient time.
Additional information can be found on page 96.

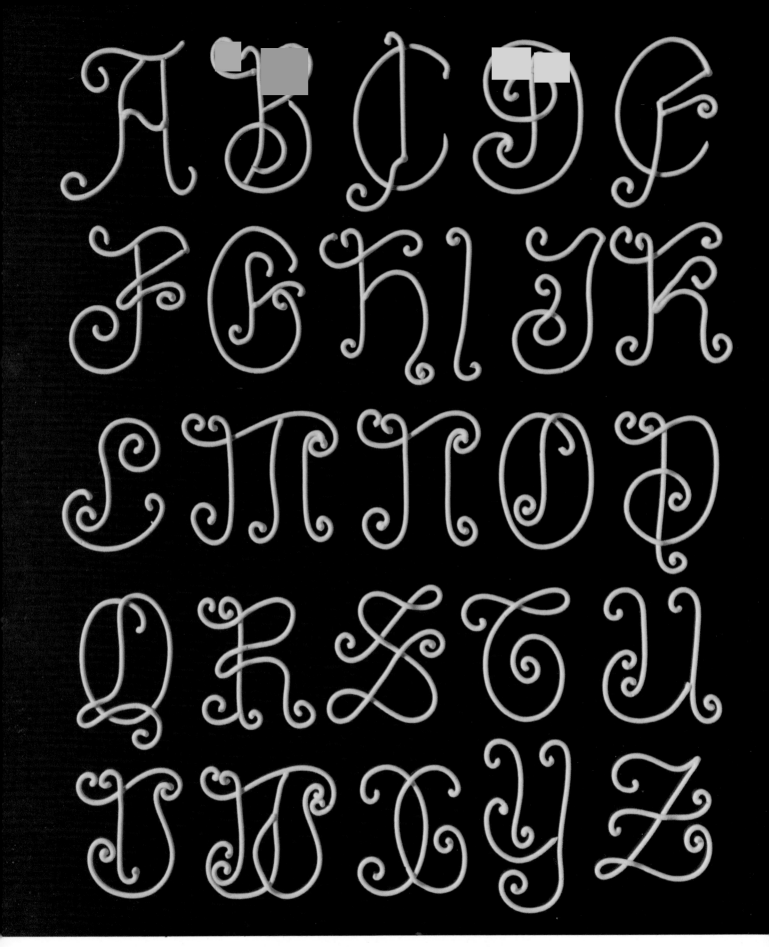

Mary Ford's Writing Style No. 19

NOTE: Before piping the artwork on this page, please study the basic instructions on pages 5 – 14 and ensure that you have the proper equipment and materials, as well as sufficient time.
Additional information can be found on page 96.

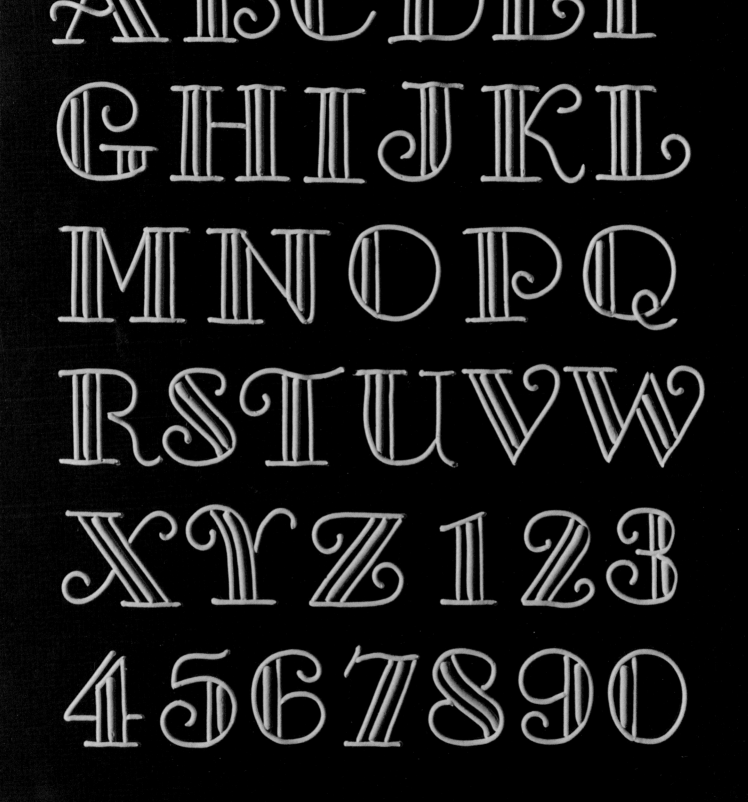

Mary Ford's Writing Style No. 20

NOTE: Before piping the artwork on this page, please study the basic instructions on pages 5 – 14 and ensure
that you have the proper equipment and materials, as well as sufficient time.
Additional information can be found on page 96.

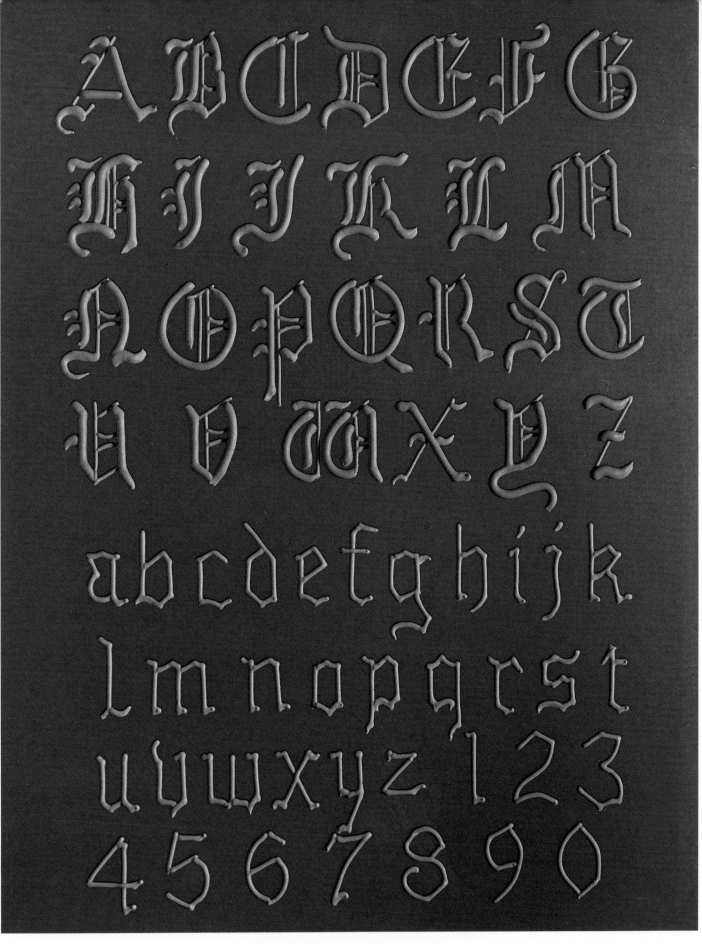

Mary Ford's Writing Style No. 21

NOTE: Before piping the artwork on this page, please study the basic instructions on pages 5 – 14 and ensure that you have the proper equipment and materials, as well as sufficient time. Additional information can be found on page 96.

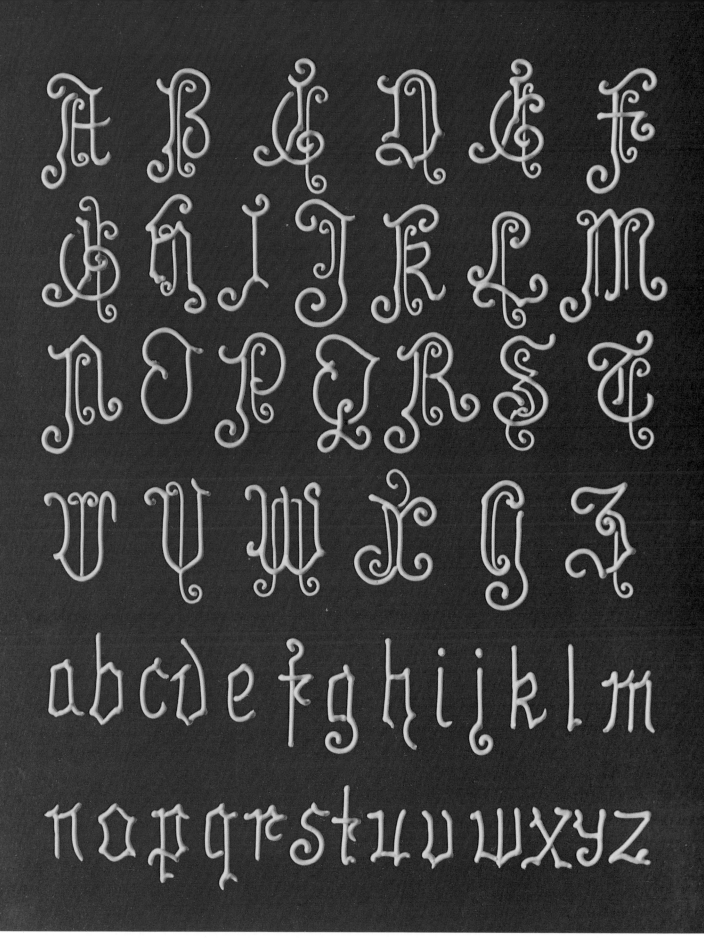

Mary Ford's Writing Style No. 22

NOTE: *Before piping the artwork on this page, please study the basic instructions on pages 5 – 14 and ensure that you have the proper equipment and materials, as well as sufficient time.*
Additional information can be found on page 96.

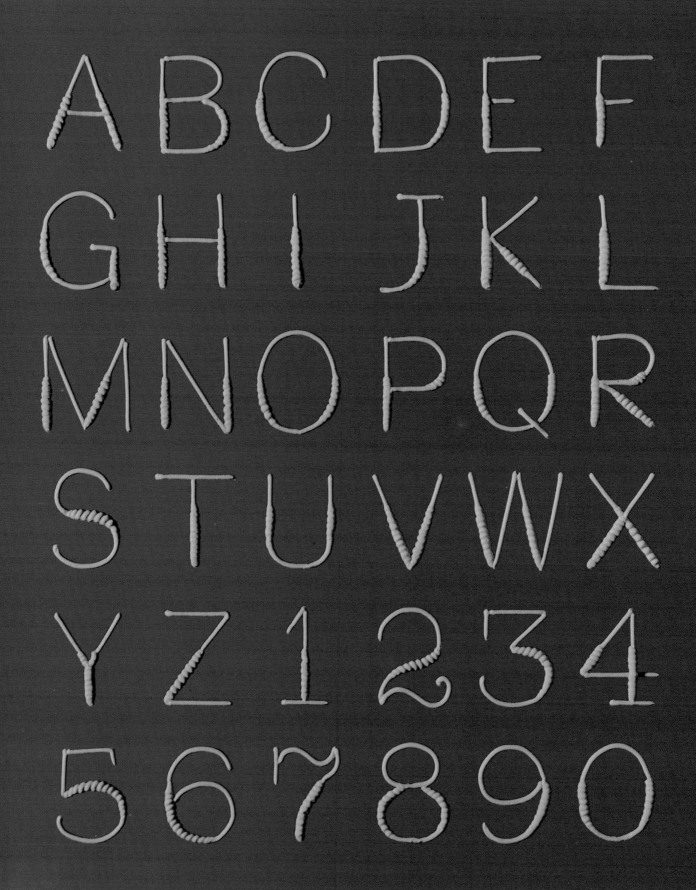

Mary Ford's Writing Style No. 23

NOTE: Before piping the artwork on this page, please study the basic instructions on pages 5 – 14 and ensure
that you have the proper equipment and materials, as well as sufficient time.
Additional information can be found on page 96.

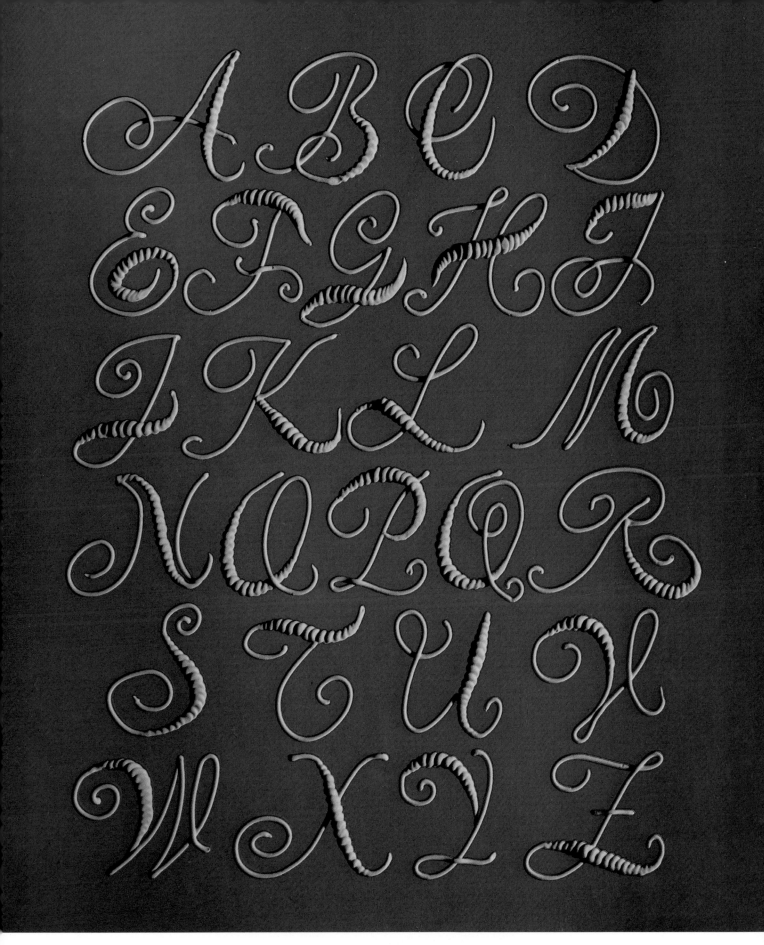

Mary Ford's Writing Style No. 24

NOTE: Before piping the artwork on this page, please study the basic instructions on pages 5 – 14 and ensure that you have the proper equipment and materials, as well as sufficient time.
Additional information can be found on page 96.

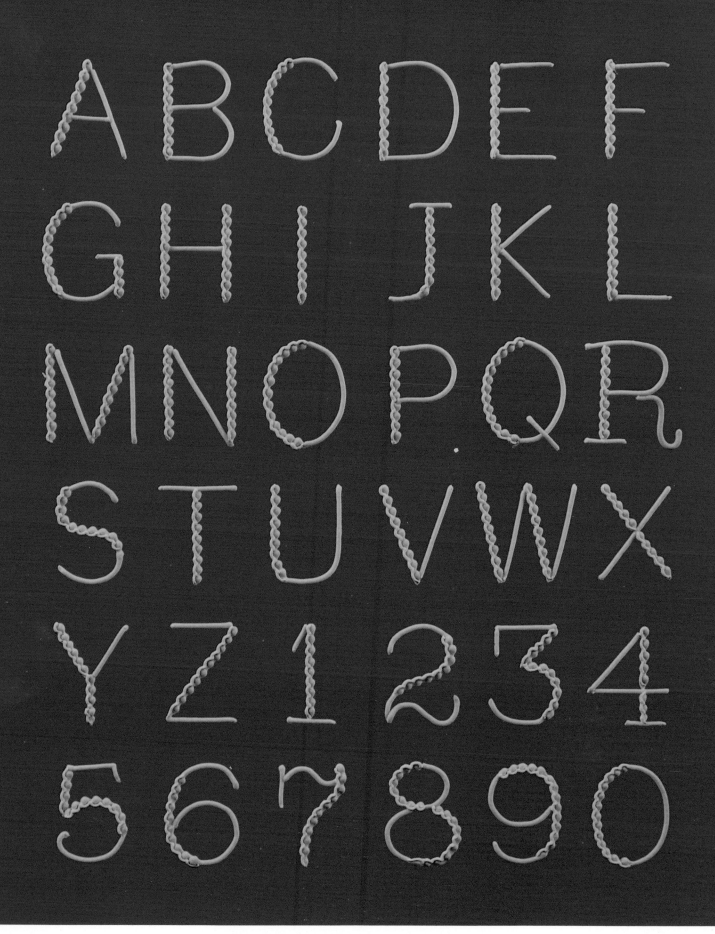

Mary Ford's Writing Style No. 25

NOTE: Before piping the artwork on this page, please study the basic instructions on pages 5 – 14 and ensure
that you have the proper equipment and materials, as well as sufficient time.
Additional information can be found on page 96.

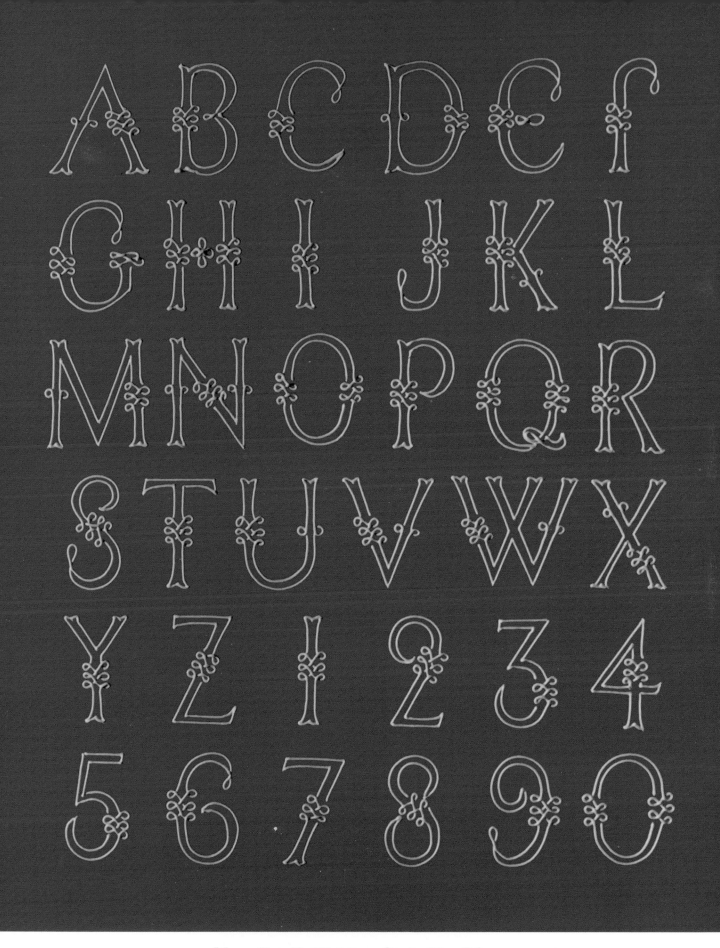

Mary Ford's Writing Style No. 26

NOTE: Before piping the artwork on this page, please study the basic instructions on pages 5 – 14 and ensure that you have the proper equipment and materials, as well as sufficient time.
Additional information can be found on page 96.

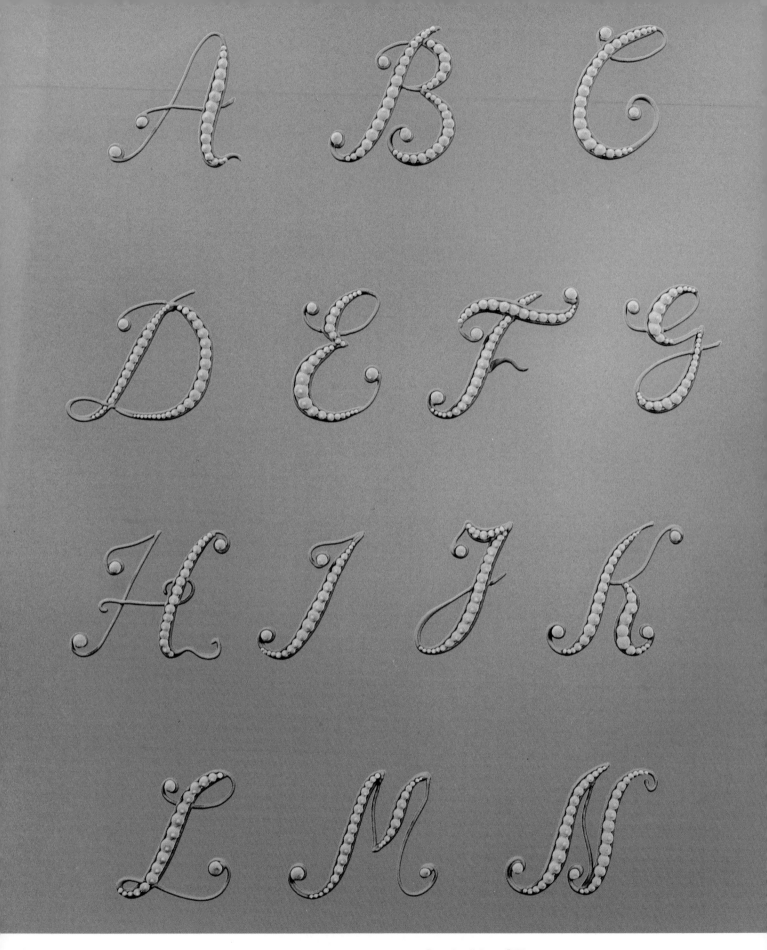

Mary Ford's Writing Style No. 27

NOTE: Before piping the artwork on this page, please study the basic instructions on pages 5 – 14 and ensure that you have the proper equipment and materials, as well as sufficient time. Additional information can be found on page 96.

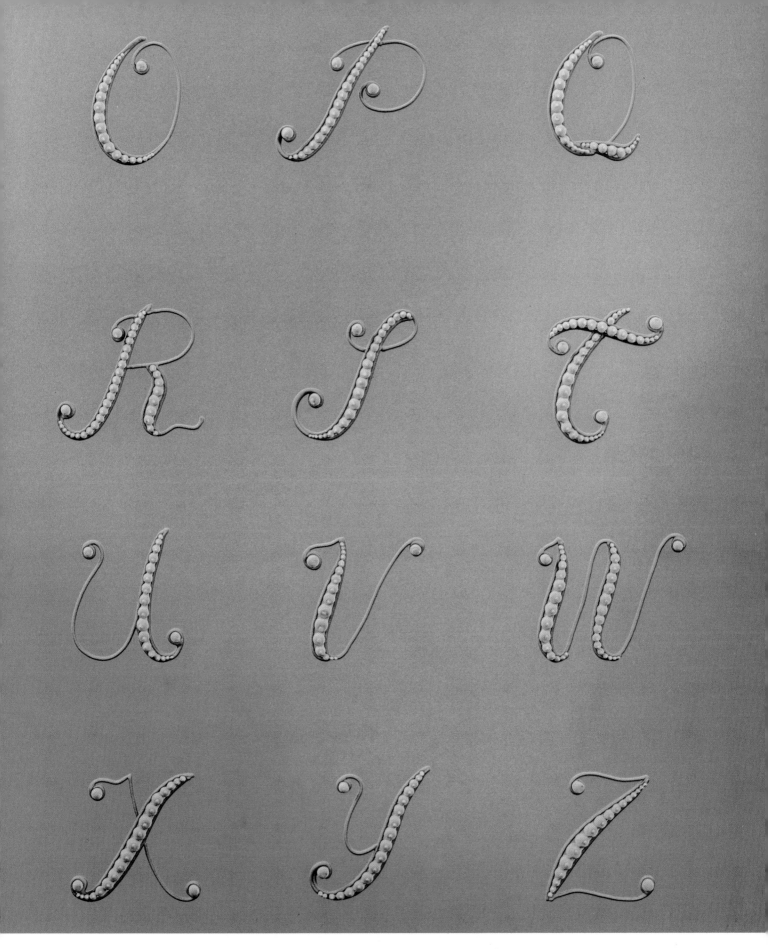

Mary Ford's Writing Style No. 27

NOTE: Before piping the artwork on this page, please study the basic instructions on pages 5 – 14 and ensure that you have the proper equipment and materials, as well as sufficient time. Additional information can be found on page 96.

A B C D E

F G H I J

K L M N O

P Q R S T

U V W X Y

Z 1 2 3 4 5

6 7 8 9 0 &

Mary Ford's Runout Writing Style No. 28

NOTE: Before piping the artwork on this page, please study the basic instructions on pages 5 – 14 and ensure that you have the proper equipment and materials, as well as sufficient time.
Additional information can be found on page 96.

ABCDEFG
HIJKLMN
OPQRSTU
VWXYZ12
34567890

Mary Ford's Runout Writing Style No. 29

ABCDEFG
HIJKLMN
OPQRSTU
VWXYZab
cdefghijklmn
opqrstuvwxyz
1234567890

Mary Ford's Runout Writing Style No. 30

NOTE: Before piping the artwork on this page, please study the basic instructions on pages 5 – 14 and ensure that you have the proper equipment and materials, as well as sufficient time.
Additional information can be found on page 96.

A B C D E F
G H I J K L
M N O P Q R
S T U V W X
Y Z 1 2 3 4
5 6 7 8 9 0

Mary Ford's Runout Writing Style No. 31

NOTE: Before piping the artwork on this page, please study the basic instructions on pages 5 – 14 and ensure that you have the proper equipment and materials, as well as sufficient time. Additional information can be found on page 96.

49

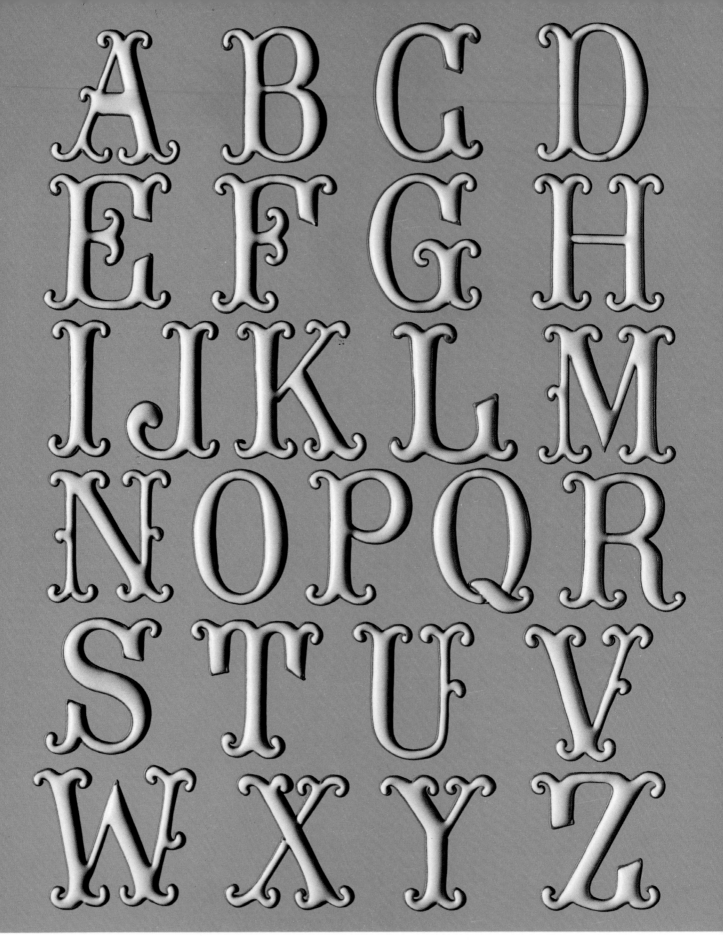

Mary Ford's Runout Writing Style No. 32

NOTE: Before piping the artwork on this page, please study the basic instructions on pages 5 – 14 and ensure that you have the proper equipment and materials, as well as sufficient time.
Additional information can be found on page 96.

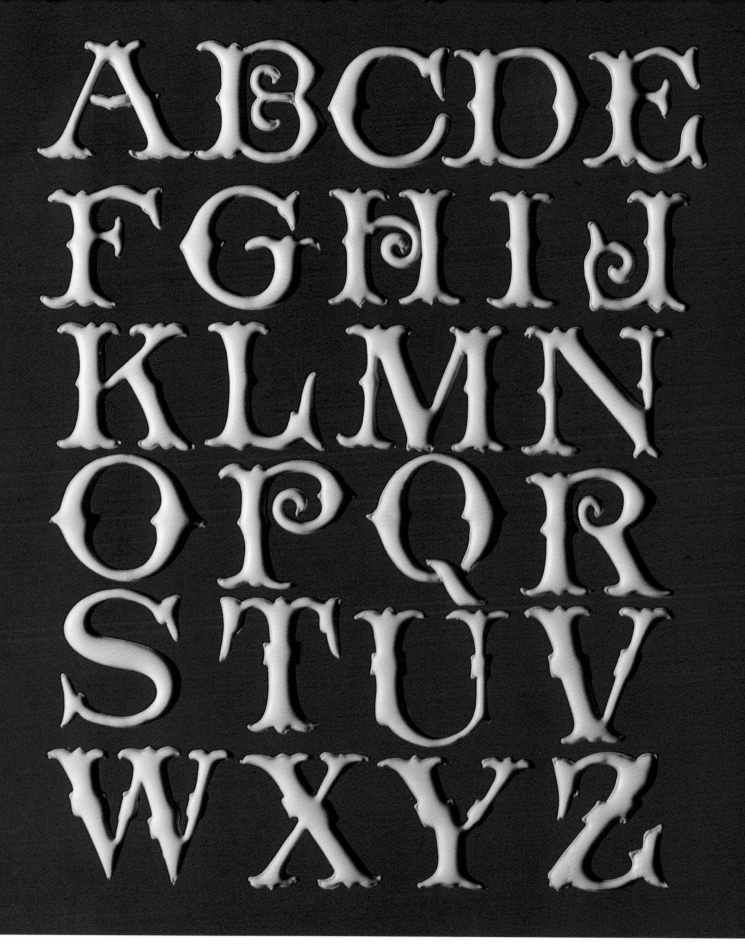

Mary Ford's Runout Writing Style No. 33

NOTE: Before piping the artwork on this page, please study the basic instructions on pages 5 – 14 and ensure that you have the proper equipment and materials, as well as sufficient time.
Additional information can be found on page 96.

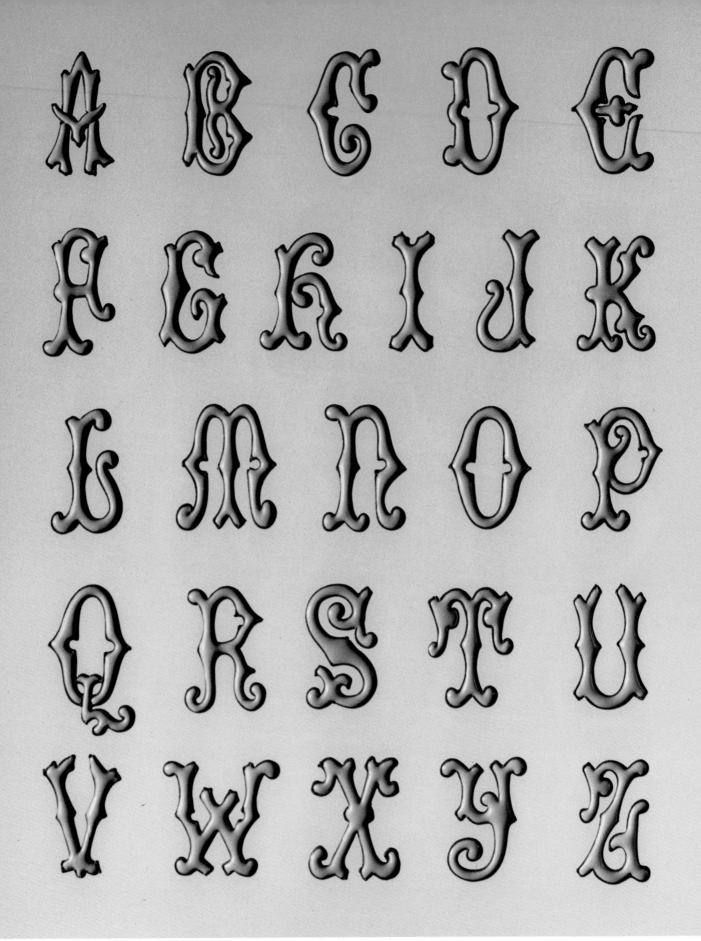

Mary Ford's Runout Writing Style No. 34

NOTE: Before piping the artwork on this page, please study the basic instructions on pages 5 – 14 and ensure that you have the proper equipment and materials, as well as sufficient time. Additional information can be found on page 96.

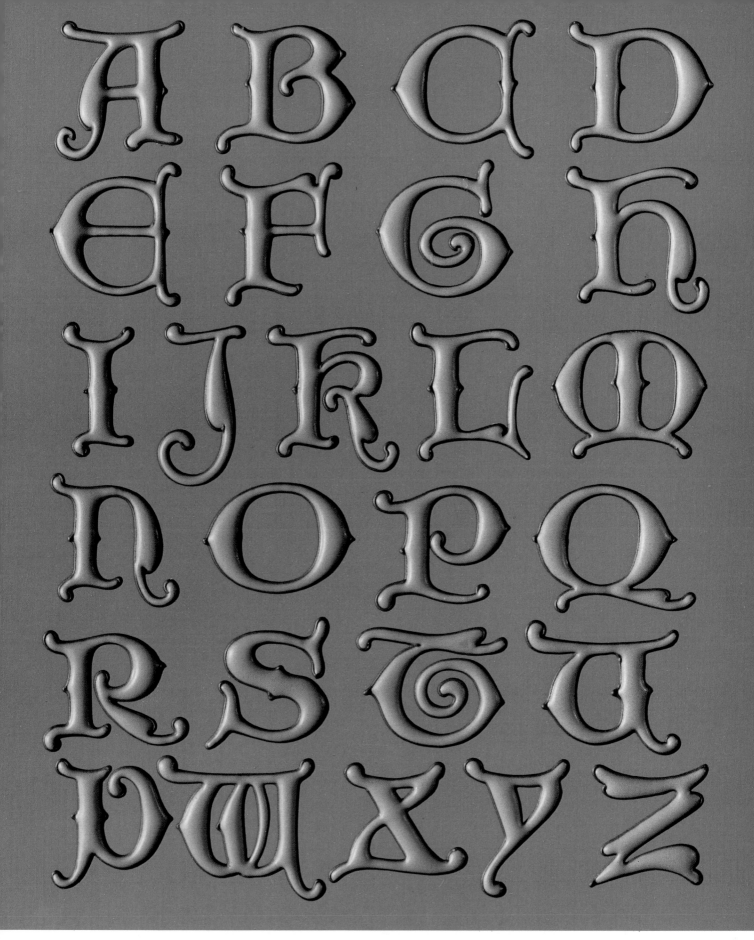

Mary Ford's Runout Writing Style No. 35

NOTE: Before piping the artwork on this page, please study the basic instructions on pages 5 – 14 and ensure
that you have the proper equipment and materials, as well as sufficient time.
Additional information can be found on page 96.

53

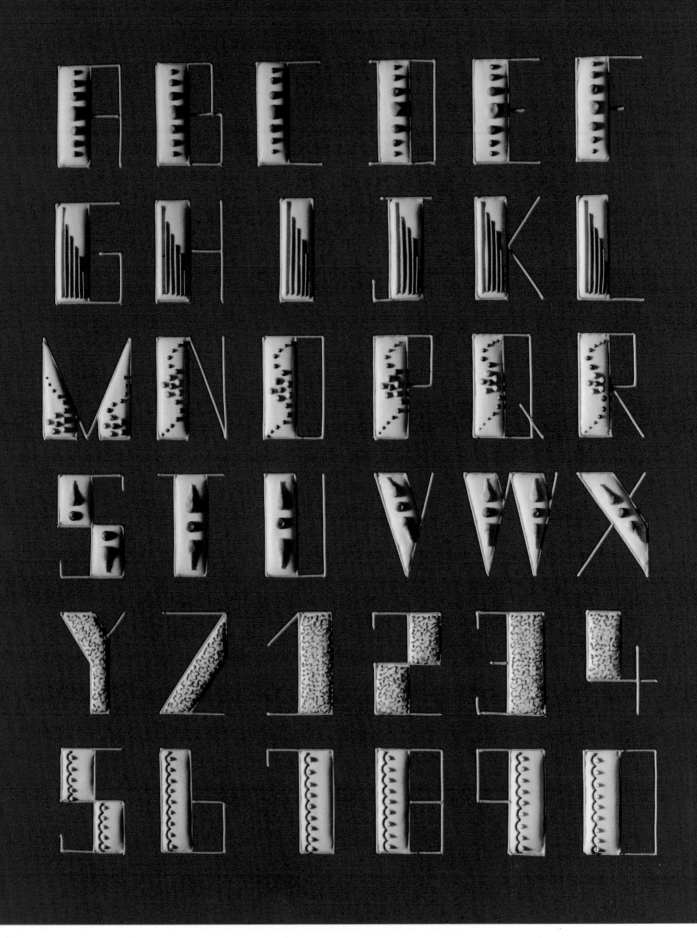

Mary Ford's Runout Writing Style No. 36

NOTE: Before piping the artwork on this page, please study the basic instructions on pages 5 – 14 and ensure that you have the proper equipment and materials, as well as sufficient time.
Additional information can be found on page 96.

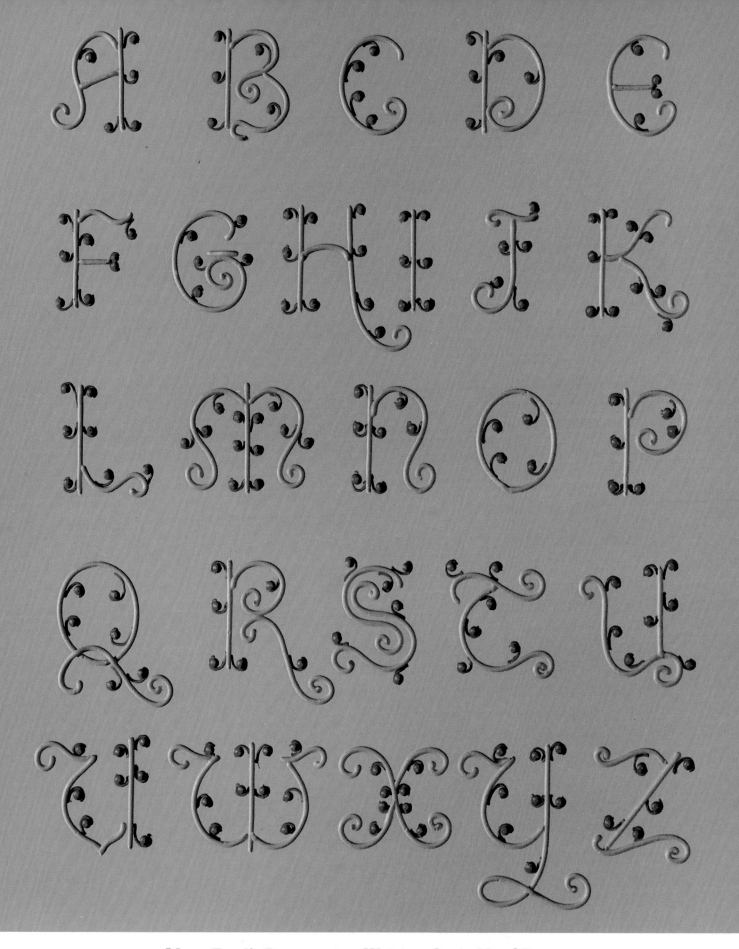

Mary Ford's Decorative Writing Style No. 37

NOTE: Before piping the artwork on this page, please study the basic instructions on pages 5 – 14 and ensure that you have the proper equipment and materials, as well as sufficient time. Additional information can be found on page 96.

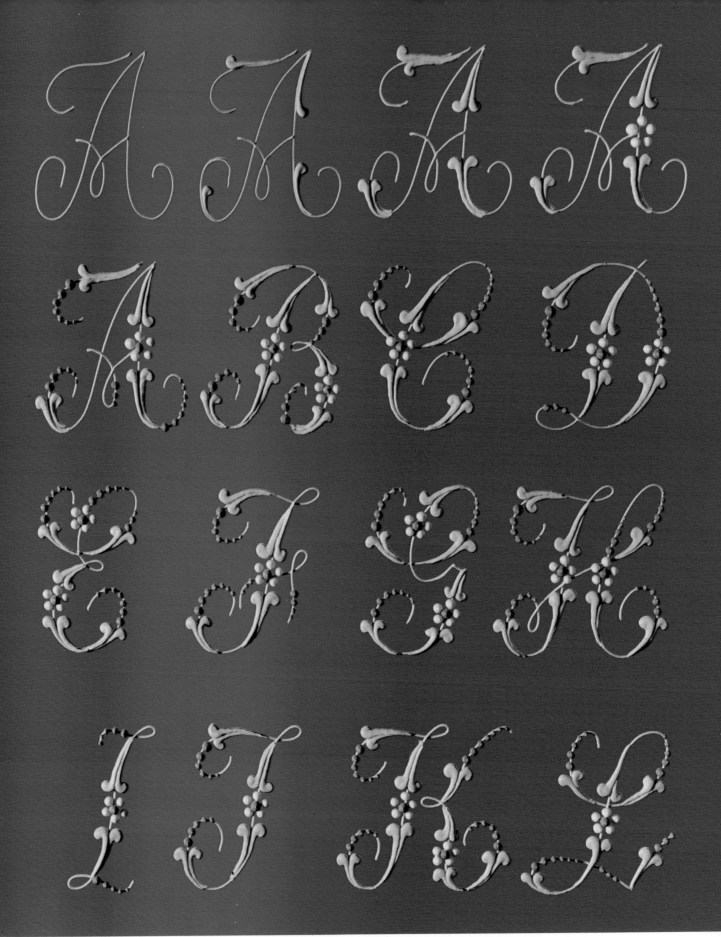

Mary Ford's Decorative Writing Style No. 38

Follow the sequence shown on 'A' to achieve the completed letter.

NOTE: Before piping the artwork on this page, please study the basic instructions on pages 5 – 14 and ensure that you have the proper equipment and materials, as well as sufficient time.
Additional information can be found on page 96.

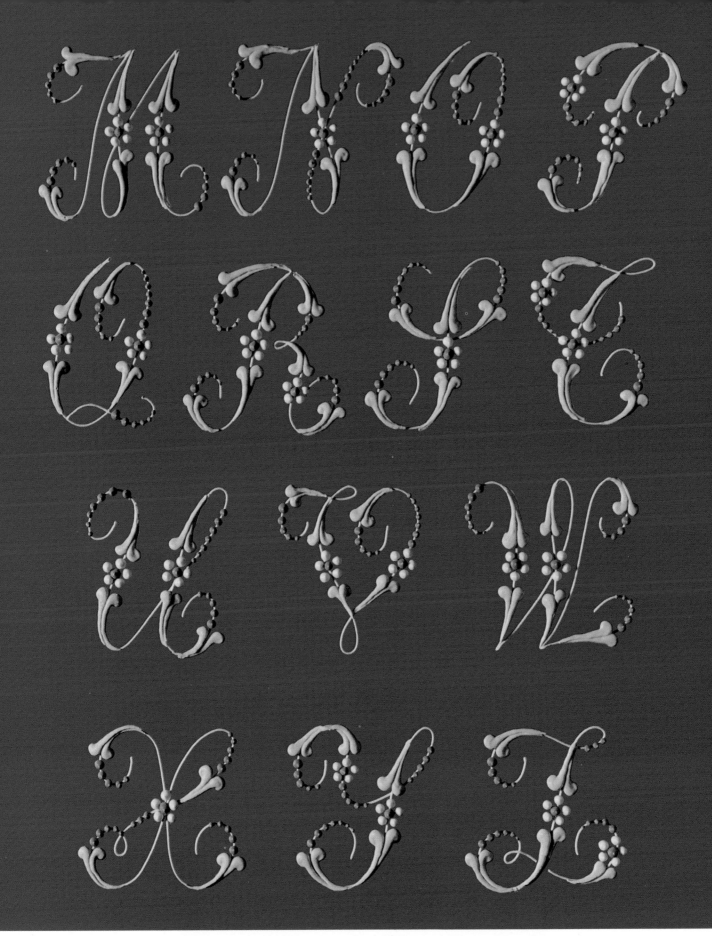

Mary Ford's Decorative Writing Style No. 38

Follow the sequence shown on 'A' to achieve the completed letter.

NOTE: Before piping the artwork on this page, please study the basic instructions on pages 5 – 14 and ensure that you have the proper equipment and materials, as well as sufficient time.
Additional information can be found on page 96.

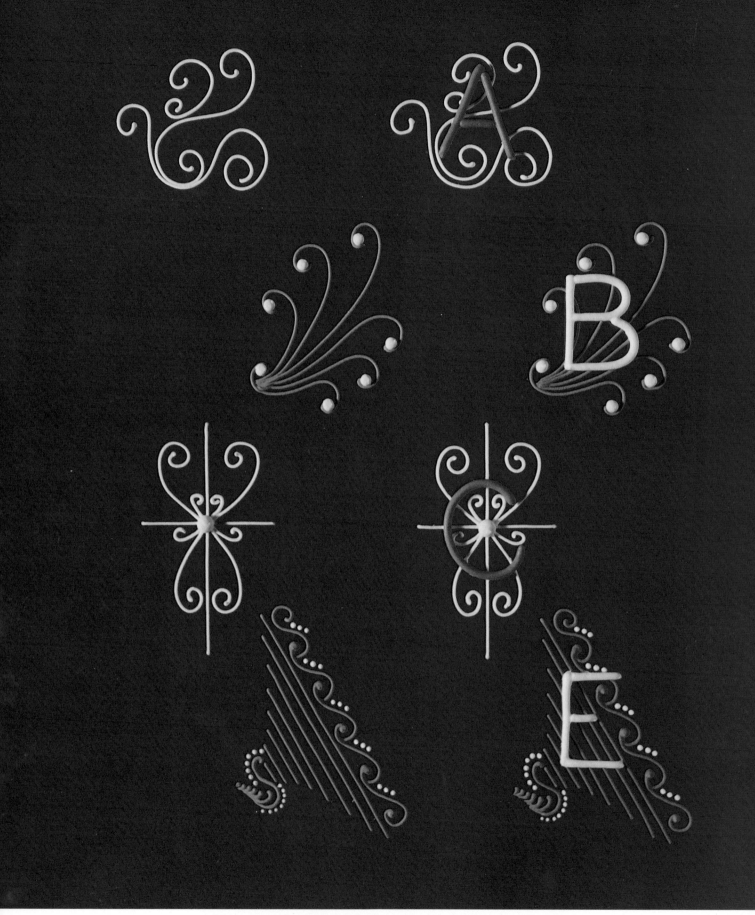

Mary Ford's Decorative Writing Style No. 39

Pipe the background design first. When dry − pipe letter on to design.

NOTE: Before piping the artwork on this page, please study the basic instructions on pages 5 − 14 and ensure that you have the proper equipment and materials, as well as sufficient time. Additional information can be found on page 96.

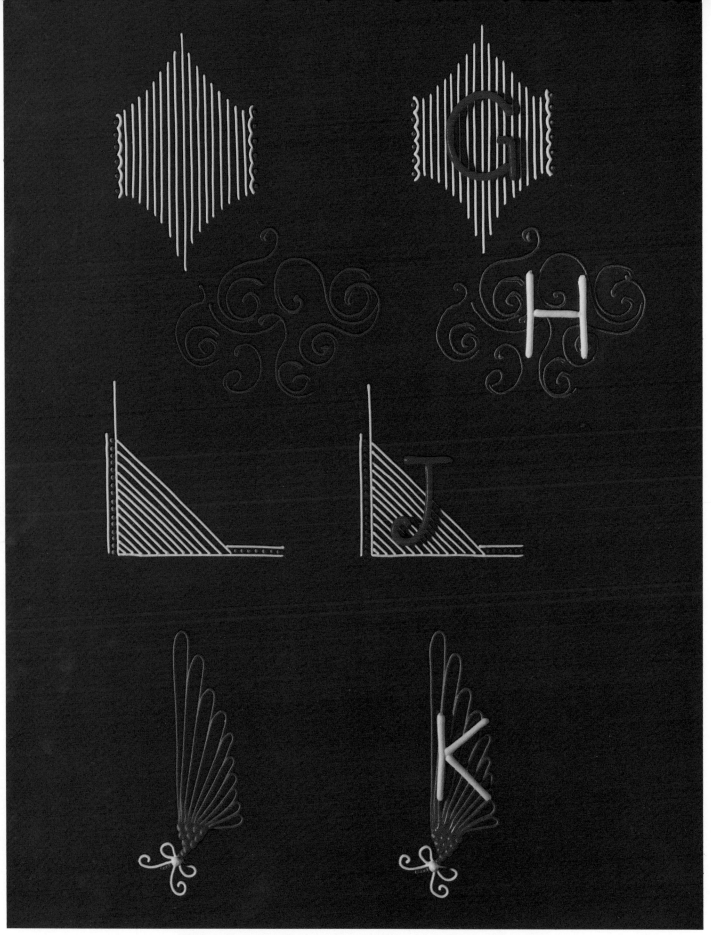

Mary Ford's Decorative Writing Style No. 40

Pipe the background design first. When dry — pipe letter on to design.

NOTE: Before piping the artwork on this page, please study the basic instructions on pages 5 — 14 and ensure that you have the proper equipment and materials, as well as sufficient time. Additional information can be found on page 96.

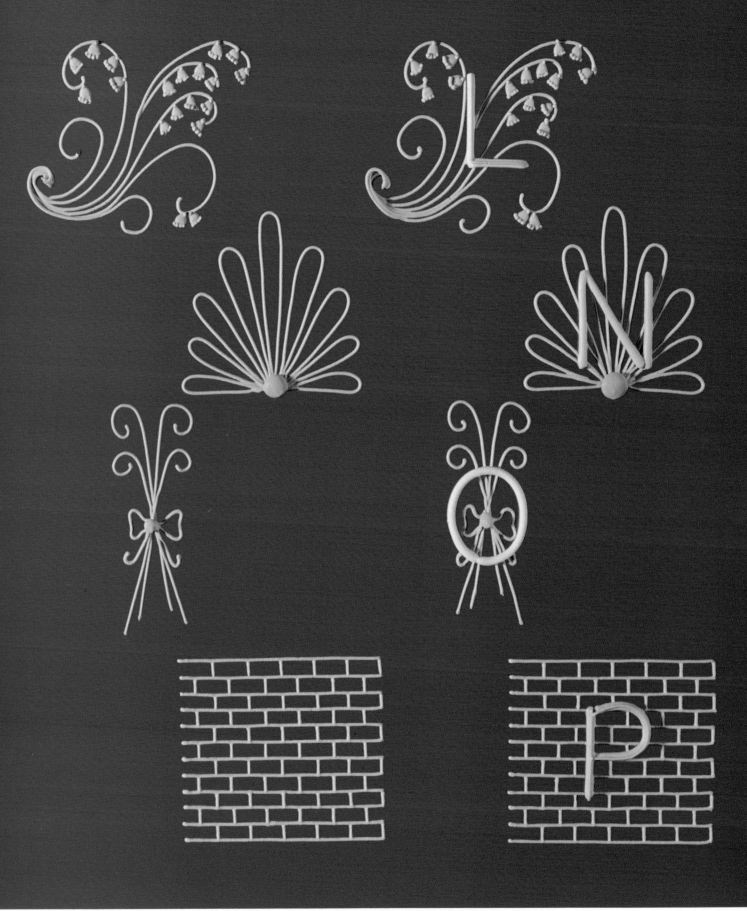

Mary Ford's Decorative Writing Style No. 41

Pipe the background design first. When dry – pipe letter on to design.

NOTE: Before piping the artwork on this page, please study the basic instructions on pages 5 – 14 and ensure that you have the proper equipment and materials, as well as sufficient time. Additional information can be found on page 96.

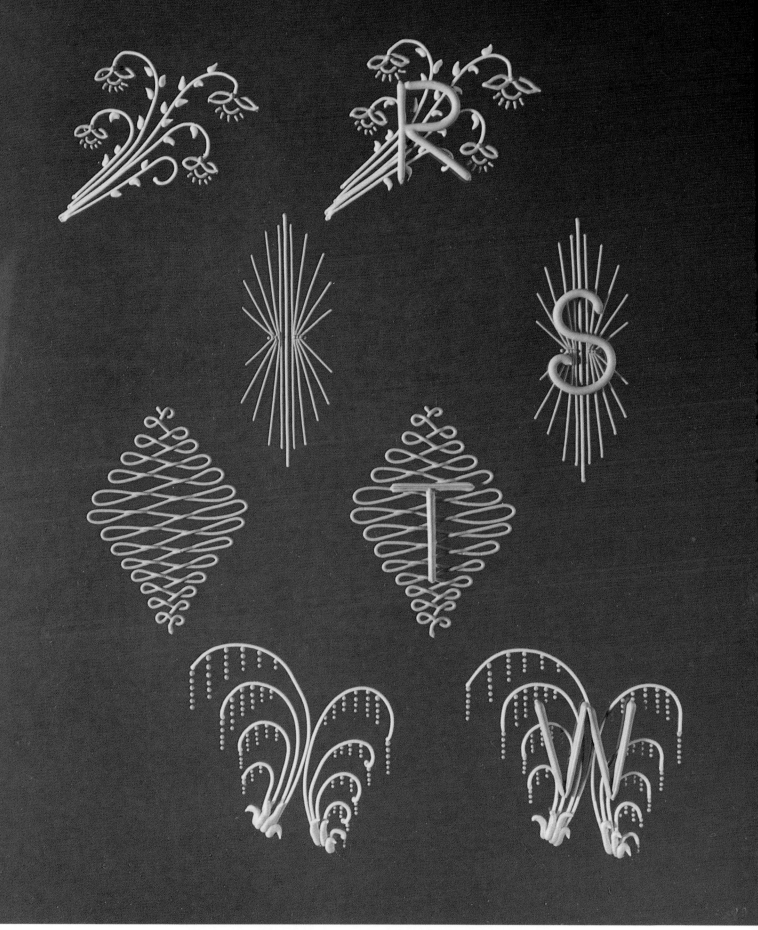

Mary Ford's Decorative Writing Style No. 42

Pipe the background design first. When dry – pipe letter on to design.

NOTE: Before piping the artwork on this page, please study the basic instructions on pages 5 – 14 and ensure that you have the proper equipment and materials, as well as sufficient time.
Additional information can be found on page 96.

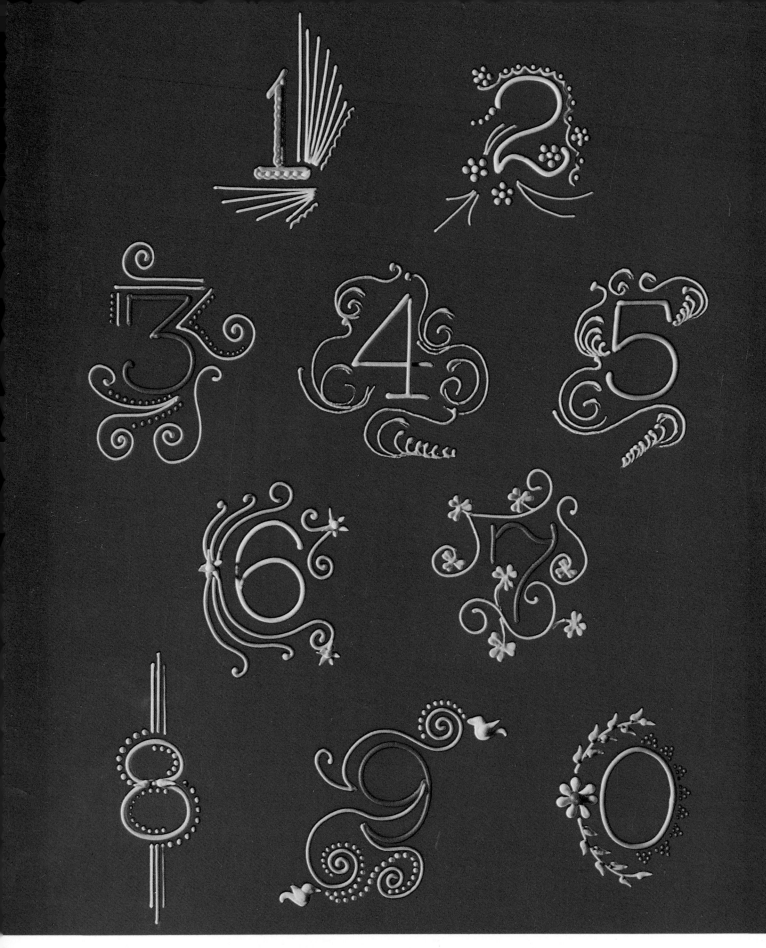

Mary Ford's Decorative Writing Style No. 43

NOTE: Before piping the artwork on this page, please study the basic instructions on pages 5 – 14 and ensure that you have the proper equipment and materials, as well as sufficient time. Additional information can be found on page 96.

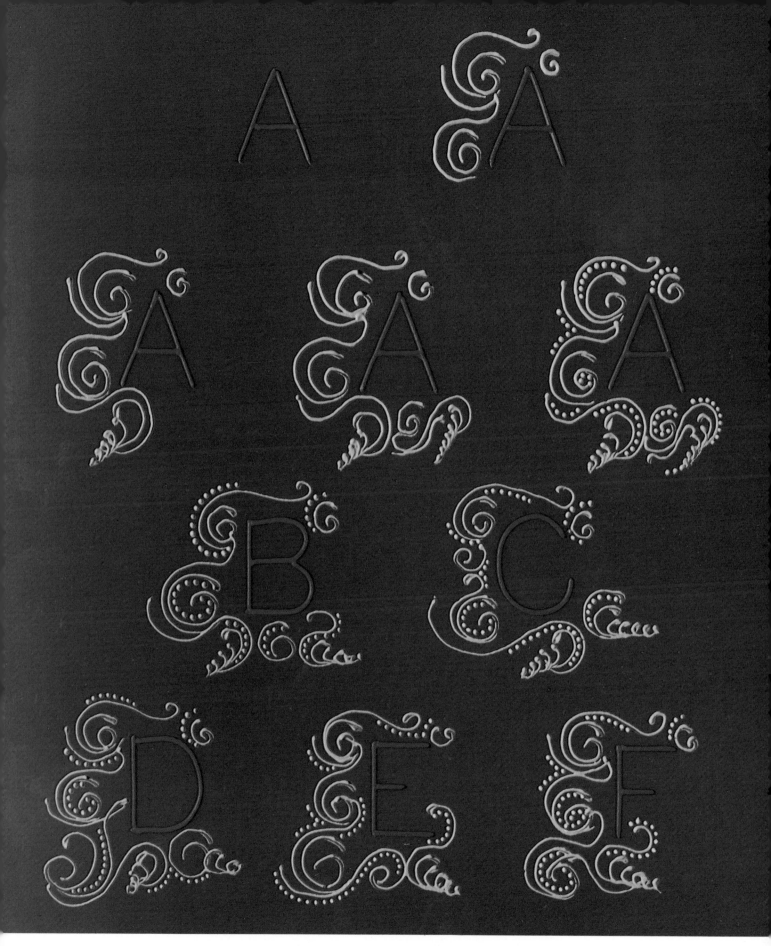

Mary Ford's Decorative Writing Style No. 44

NOTE: Before piping the artwork on this page, please study the basic instructions on pages 5 – 14 and ensure that you have the proper equipment and materials, as well as sufficient time.
Additional information can be found on page 96.

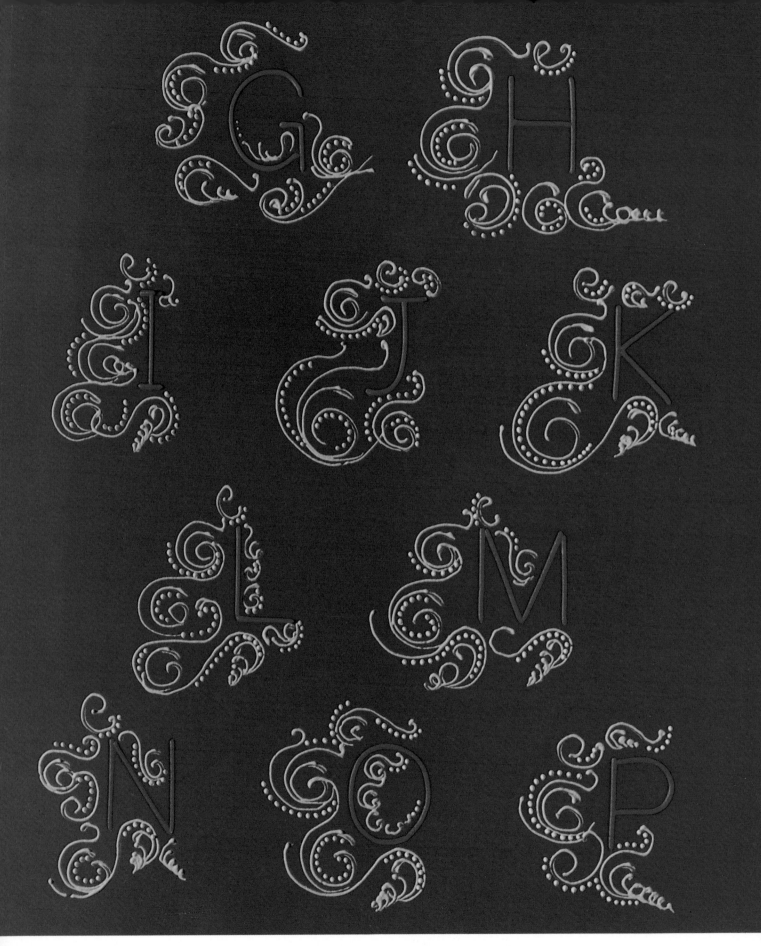

Mary Ford's Decorative Writing Style No. 44

NOTE: Before piping the artwork on this page, please study the basic instructions on pages 5 – 14 and ensure that you have the proper equipment and materials, as well as sufficient time.
Additional information can be found on page 96.

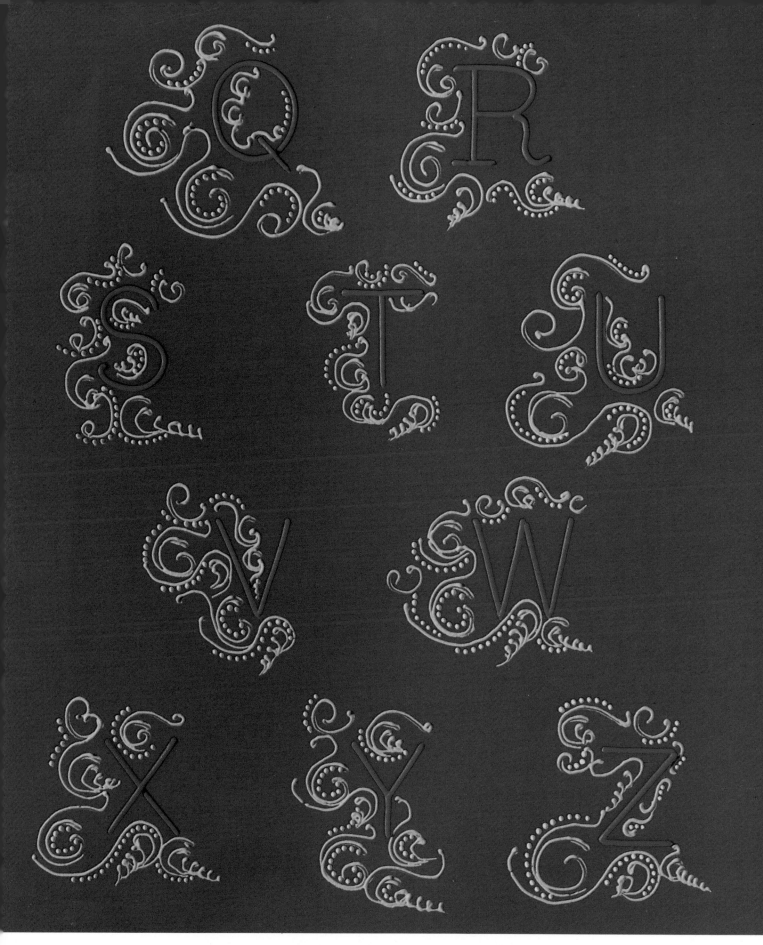

Mary Ford's Decorative Writing Style No. 44

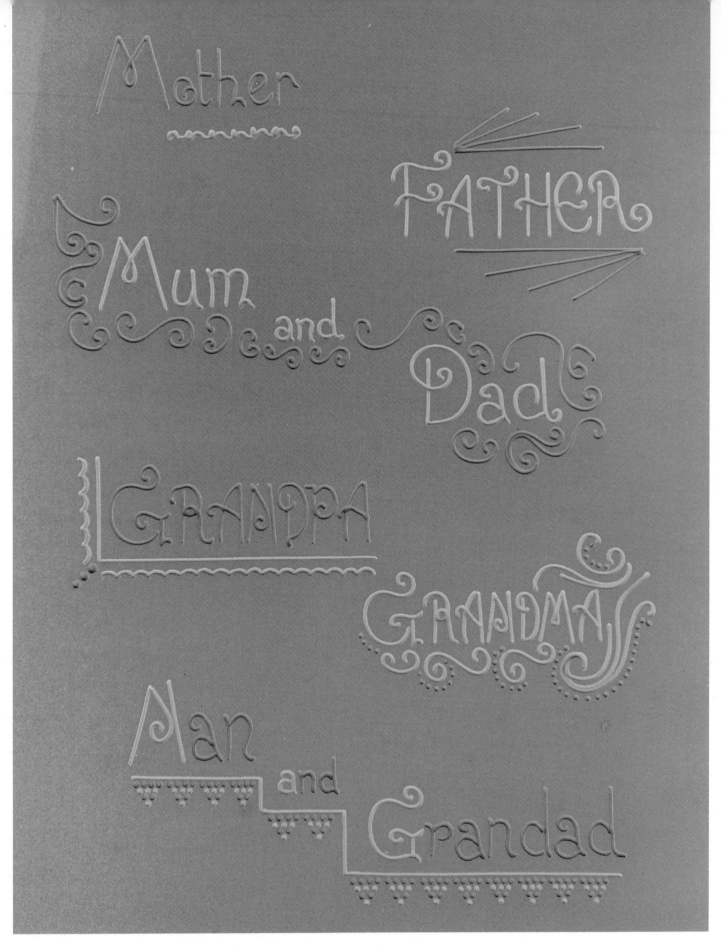

Mary Ford's Decorative Names Style No. 45

NOTE: Before piping the artwork on this page, please study the basic instructions on pages 5 – 14 and ensure
that you have the proper equipment and materials, as well as sufficient time.
Additional information can be found on page 96.

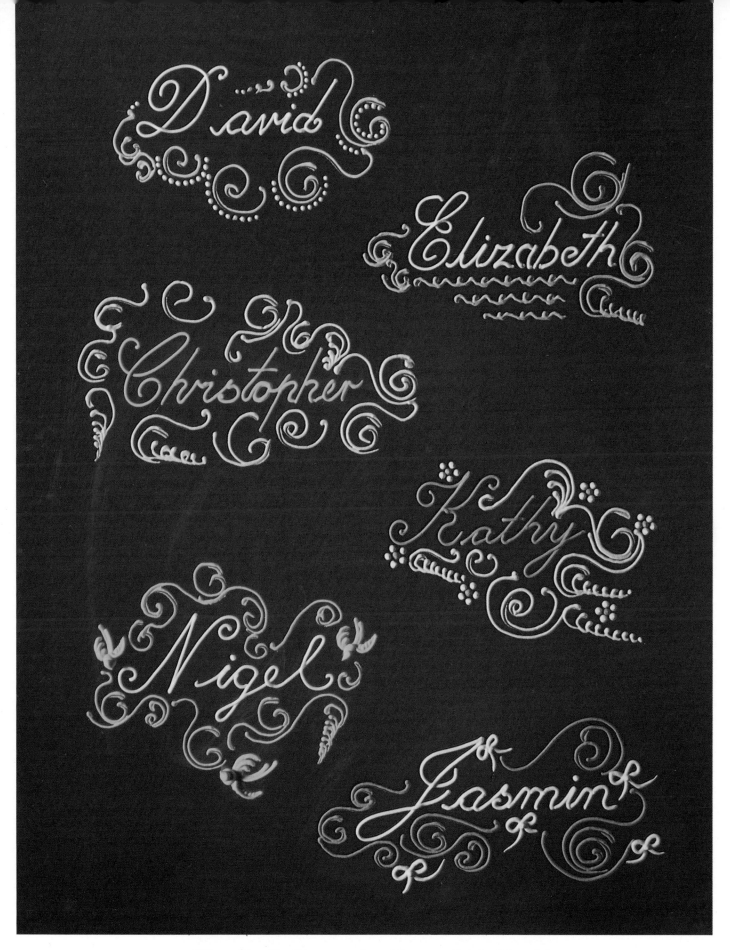

Mary Ford's Decorative Names Style No. 46

NOTE: Before piping the artwork on this page, please study the basic instructions on pages 5 – 14 and ensure that you have the proper equipment and materials, as well as sufficient time. Additional information can be found on page 96.

Happy Birthday

Best Wishes

Best Wishes

Best Wishes

Mary Ford's Inscriptions

CONGRATULATIONS

Congratulations

Congratulations

Happy ANNIVERSARY

HAPPY ANNIVERSARY

Happy Anniversary

Mary Ford's Inscriptions

NOTE: Before piping the artwork on this page, please study the basic instructions on pages 5 – 14 and ensure that you have the proper equipment and materials, as well as sufficient time. Additional information can be found on page 96.

Many Happy Returns

MANY HAPPY RETURNS

GOOD LUCK

GoodLuck

Happy Retirement

A HAPPY RETIREMENT

Mary Ford's Inscriptions

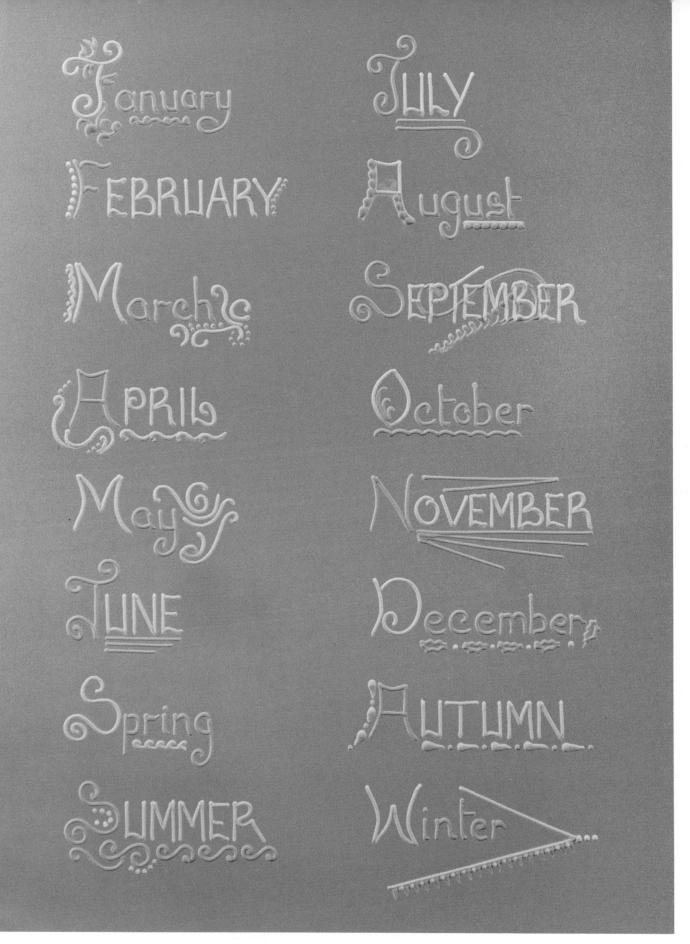

Mary Ford's Inscriptions

NOTE: Before piping the artwork on this page, please study the basic instructions on pages 5 – 14 and ensure that you have the proper equipment and materials, as well as sufficient time. Additional information can be found on page 96.

Wedding Anniversaries

1st Cotton	14th Ivory	
2nd Paper	15th Crystal	
3rd Leather	20th China	
4th Fruit, Flower	25th Silver	
5th Wooden	30th Pearl	
6th Sugar	35th Coral	
7th Woollen	40th Ruby	
8th Bronze, Pottery	45th Sapphire	
9th Willow Pottery	50th Golden	
10th Tin	55th Emerald	
11th Steel	60th Diamond	
12th Silk, Linen	65th Blue Sapphire	
13th Lace	70th Platinum	

Mary Ford's Inscriptions

NOTE: Before piping the artwork on this page, please study the basic instructions on pages 5 − 14 and ensure that you have the proper equipment and materials, as well as sufficient time.
Additional information can be found on page 96.

FRENCH

BONNE ANNIVERSAIRE ◁ **Happy Birthday**

FÉLICITATIONS ◁ **Congratulations**

ITALIAN

BUON COMPLEANNO ◁ **Happy Birthday**

GERMAN

GEBURTSTAGSWÜNSCHE ◁ **Happy Birthday**

GRATULATION ◁ **Congratulations**

SPANISH

FELIZ CUMPLEAÑOS ◁ **Happy Birthday**

FELICITACIÓNES ◁ **Congratulations**

DUTCH

HARTELIJK GEFELICITEERD ◁ **Happy Birthday**

SWEDISH

GRATULERAR PAFODELSEDAGEN ◁ **Congratulations on your Birthday**

Mary Ford's Inscriptions

NOTE: Before piping the artwork on this page, please study the basic instructions on pages 5 – 14 and ensure that you have the proper equipment and materials, as well as sufficient time. Additional information can be found on page 96.

25 Happy Years

50 Golden Years

Bon Voyage

Welcome Home

Sarah

NOTE: Before piping the artwork on this page, please study the basic instructions on pages 5 – 14 and ensure that you have the proper equipment and materials, as well as sufficient time. Additional information can be found on page 96.

HAPPY EASTER

Easter Greetings

Father's Day

To Mother

To My Valentine

On Your Engagement

Mary Ford's Inscriptions

NOTE: Before piping the artwork on this page, please study the basic instructions on pages 5 – 14 and ensure that you have the proper equipment and materials, as well as sufficient time. Additional information can be found on page 96.

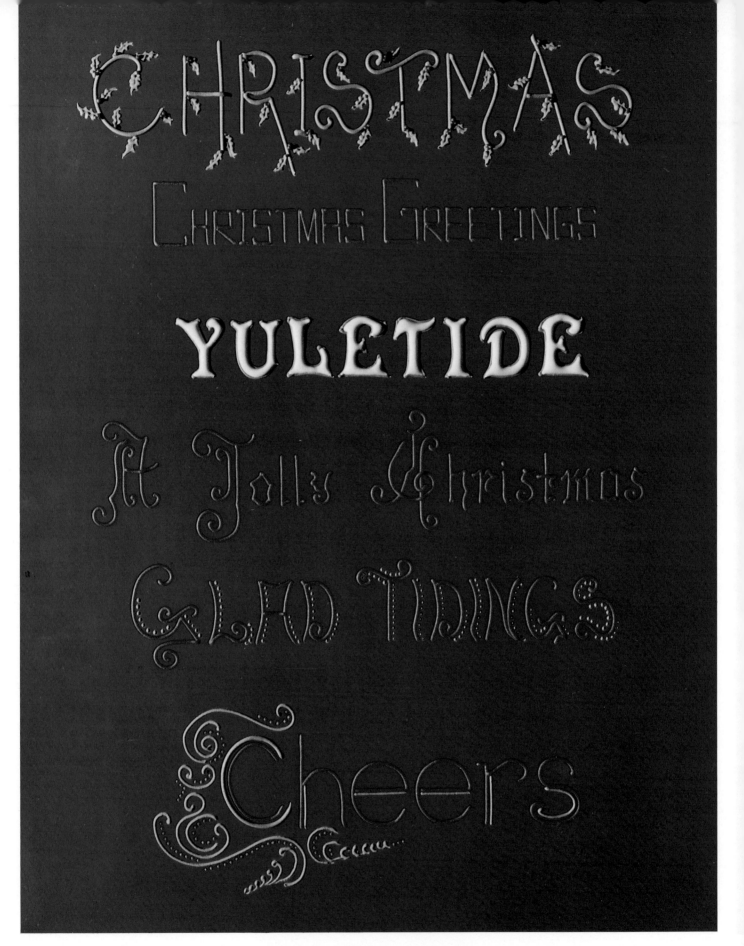

Mary Ford's Inscriptions

NOTE: Before piping the artwork on this page, please study the basic instructions on pages 5 – 14 and ensure that you have the proper equipment and materials, as well as sufficient time. Additional information can be found on page 96.

Merry Christmas

Good Will To All Men

Noel

With Every Good Wish For A Happy Christmas And Prosperous New Year

A Happy Christmas

The Seasons Greetings

Mary Ford's Inscriptions

NOTE: Before piping the artwork on this page, please study the basic instructions on pages 5 – 14 and ensure that you have the proper equipment and materials, as well as sufficient time. Additional information can be found on page 96.

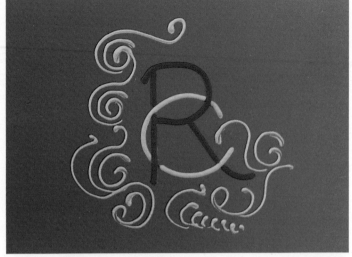

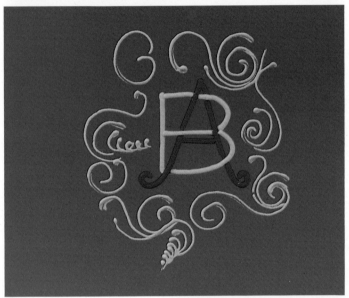

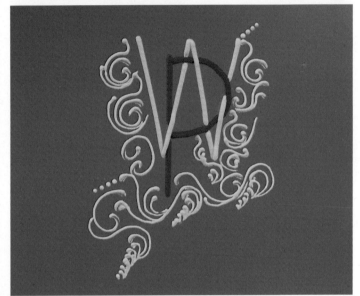

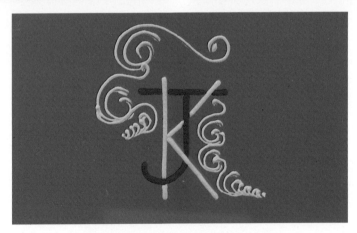

Mary Ford's Monograms

Before piping a monogram on to a cake top or cake side, draw the chosen initials on a sheet of paper using two colours, one for each initial. By breaking the flow of a line in an initial, an under-and-over effect will be created. The monogram style can be varied by elongating the initials (as in the "ST") or by reducing the size of one of the initials (as in the "RC").

NOTE: Before piping the artwork on this page, please study the basic instructions on pages 5 – 14 and ensure that you have the proper equipment and materials, as well as sufficient time. Additional information can be found on page 96.

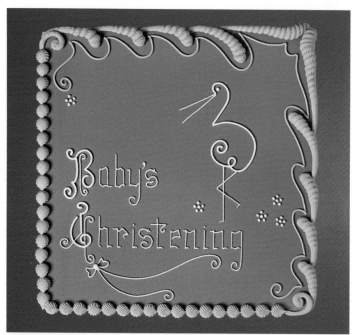

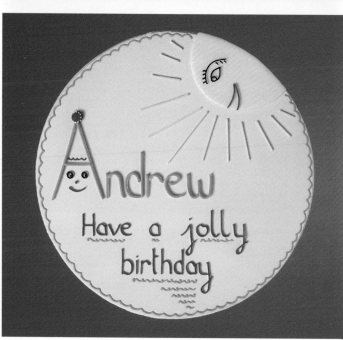

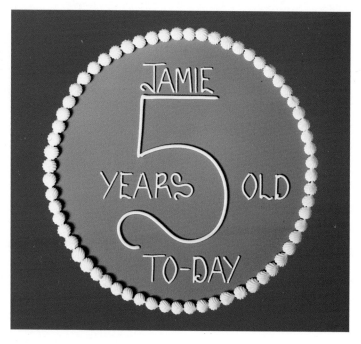

A. The stork is an example of creative piping, using straight and curved lines.

B. Simple piped lines form this candle for baby's first birthday.

C. Enhance the first letter of the name by decorating it for the appropriate occasion.

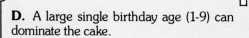

D. A large single birthday age (1-9) can dominate the cake.

Mary Ford's Decorative Cake Tops

NOTE: Before piping the artwork on this page, please study the basic instructions on pages 5 – 14 and ensure that you have the proper equipment and materials, as well as sufficient time.
Additional information can be found on page 96.

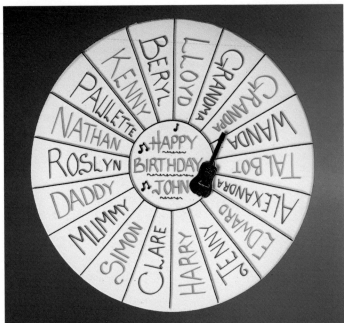

A. The invitation cake where all at the celebration are special but where John is still the centre of attraction.

B. How to pipe the inscription when the all important candles are also required.

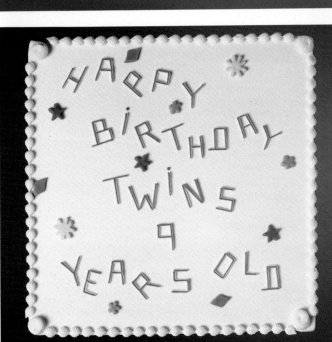

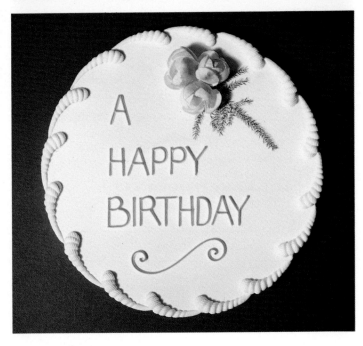

C. More of a fun cake, with no problems of straight lines and spacing, but using two colours together.

D. Plain and simple for the young and sophisticated young lady.

Mary Ford's Decorative Cake Tops

NOTE: Before piping the artwork on this page, please study the basic instructions on pages 5 – 14 and ensure that you have the proper equipment and materials, as well as sufficient time.
Additional information can be found on page 96.

80

A. Incorporating the use of an artificial decoration as part of the birthday inscription, so giving a souvenir to keep from the cake.

B. Pipe a picture of the hobby or pastime to form the design.

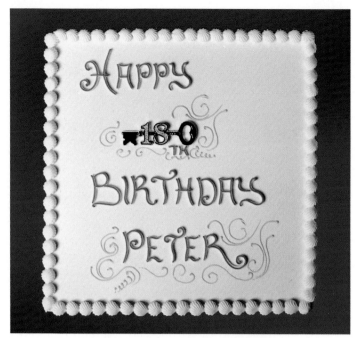

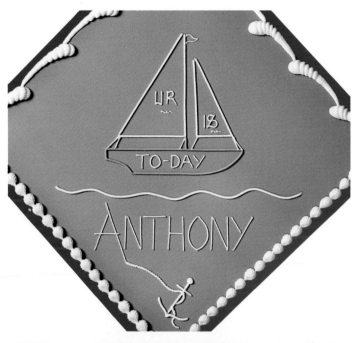

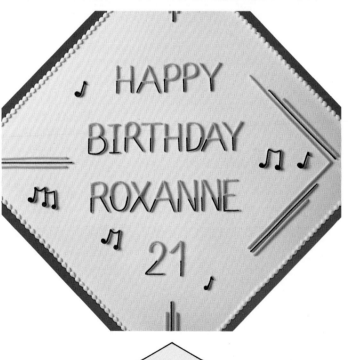

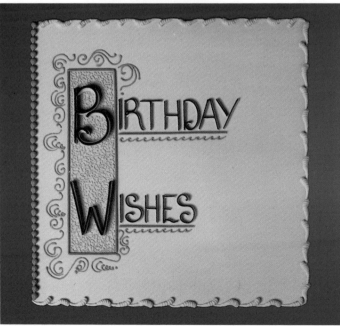

C. For the musically minded modern young person — giving the right tone to the cake.

D. For the more formal occasion. With the first two letters so highly decorated there need be no other decoration on the cake-top.

Mary Ford's Decorative Cake Tops

NOTE: Before piping the artwork on this page, please study the basic instructions on pages 5 – 14 and ensure that you have the proper equipment and materials, as well as sufficient time.
Additional information can be found on page 96.

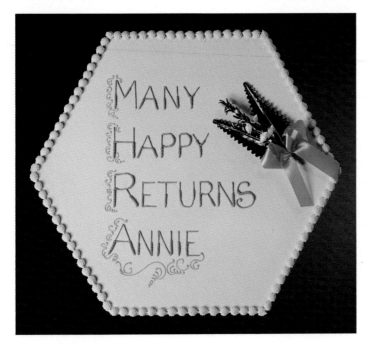

A. Delicate tracery with plain and rope writing emphasises the message.

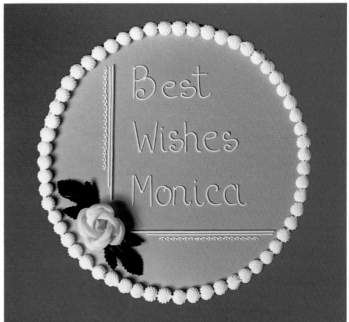

B. Border lines (page 15) are used to create a corner frame on a round cake.

C. By lengthening the first letter, two words can be brought together.

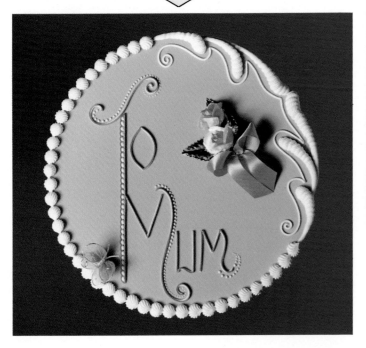

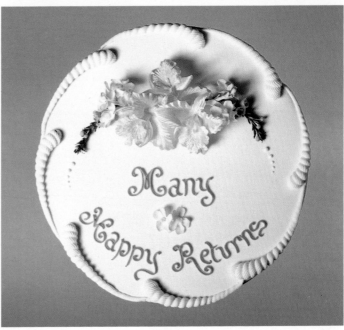

D. A cake-top bringing a touch of importance to the floral spray.

Mary Ford's Decorative Cake Tops

NOTE: Before piping the artwork on this page, please study the basic instructions on pages 5 – 14 and ensure that you have the proper equipment and materials, as well as sufficient time.
Additional information can be found on page 96.

82

A. The properly organised cake for the favourite aunty — remembering to pipe in column order!

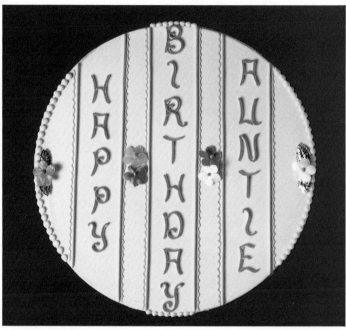

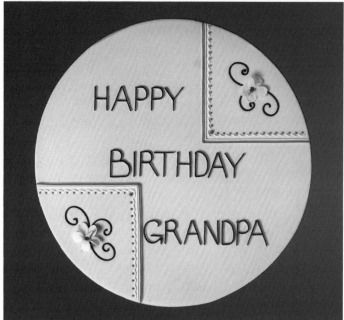

B. A way of introducing square corners on to a round cake.

C. For a retired gentleman who keeps a keen interest in cricket. But a design which can be adapted to many sports with use of the appropriate theme.

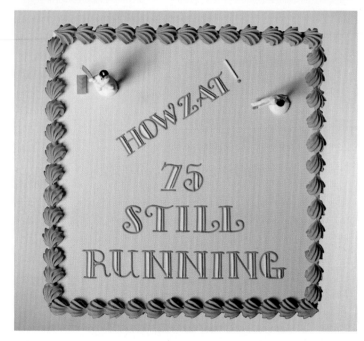

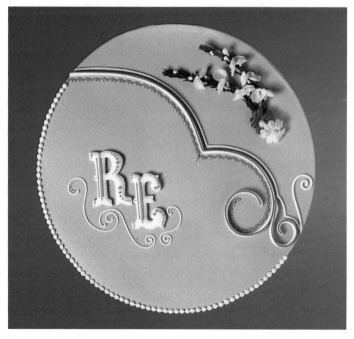

D. Introducing runout letters for a formal occasion.

Mary Ford's Decorative Cake Tops

NOTE: Before piping the artwork on this page, please study the basic instructions on pages 5 – 14 and ensure that you have the proper equipment and materials, as well as sufficient time. Additional information can be found on page 96.

83

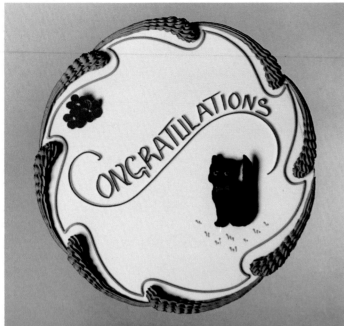

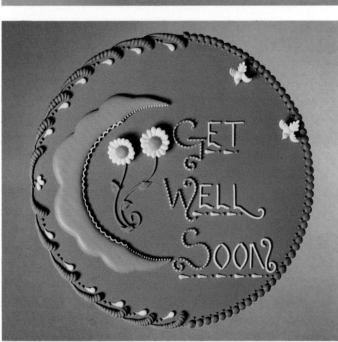

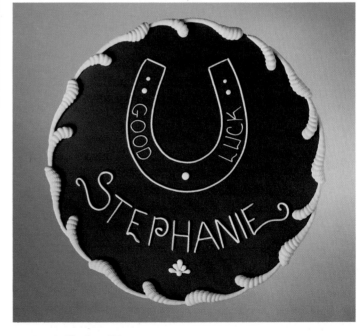

A. The length of the initial letter brings life to this inscription.

B. A runout capital letter mounted on a floral motif forms the main decoration of this cake.

C. Convey your get-well wishes with a run-out motif in a combination of piped daisies and birds.

D. No other decoration is necessary with this piped outline horseshoe.

Mary Ford's Decorative Cake Tops

NOTE: Before piping the artwork on this page, please study the basic instructions on pages 5 – 14 and ensure that you have the proper equipment and materials, as well as sufficient time. Additional information can be found on page 96.

A. An ideal design for the successful college student needing accurate piping for the long message.

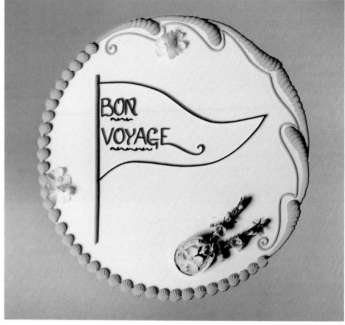

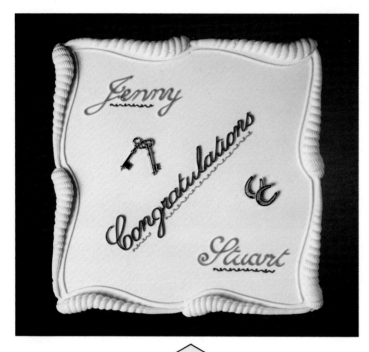

B. Use of a piped word to divide the cake diagonally into two.

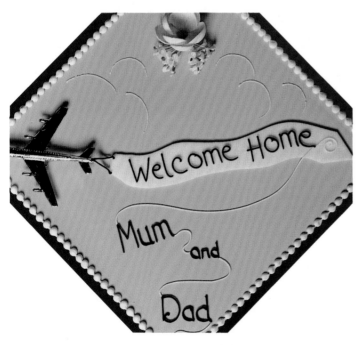

C. A piped pennant to carry the message of your choice.

D. A cake for the relation or friend returning home by air. An artificial aeroplane joins the inscription of choice.

Mary Ford's Decorative Cake Tops

NOTE: Before piping the artwork on this page, please study the basic instructions on pages 5 – 14 and ensure that you have the proper equipment and materials, as well as sufficient time. Additional information can be found on page 96.

A. When a single tier wedding cake needs a top decoration, the use of a suitable inscription can fill the cake-top.

B. This heart-shaped cake adds to the warmth of the message.

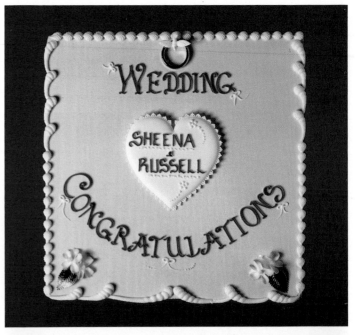

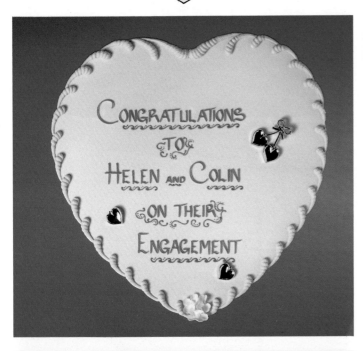

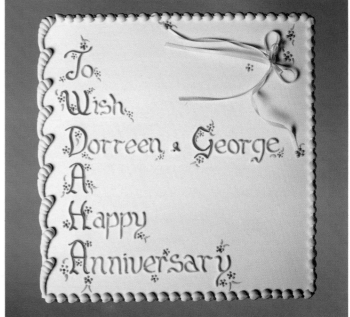

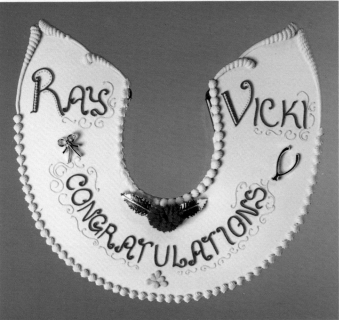

C. Floral piping highlights the message for the occasion.

D. This symbolically shaped good-luck cake can be used for an engagement, wedding, anniversary or joint birthdays.

Mary Ford's Decorative Cake Tops

NOTE: Before piping the artwork on this page, please study the basic instructions on pages 5 – 14 and ensure that you have the proper equipment and materials, as well as sufficient time. Additional information can be found on page 96.

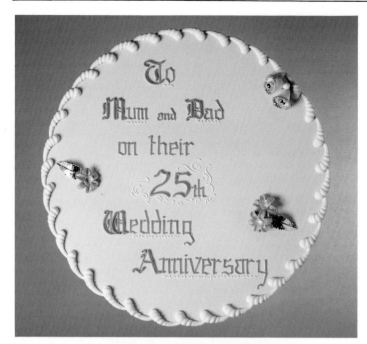

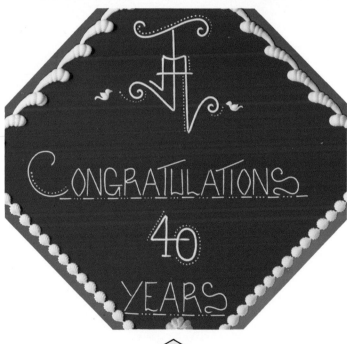

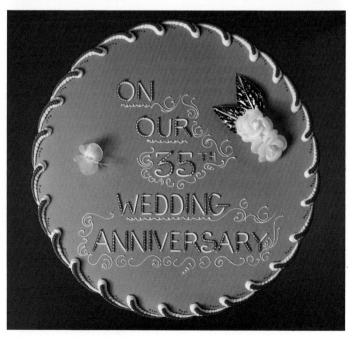

A. Old English piping for the English patriots.

B. A clear message with linked initials on a floral spray forming the centrepiece.

C. The loving couples initials are joined together in a monogram on this Ruby Wedding cake.

D. Contrasting colours for this coral anniversary cake highlight the message.

Mary Ford's Decorative Cake Tops

NOTE: *Before piping the artwork on this page, please study the basic instructions on pages 5 – 14 and ensure that you have the proper equipment and materials, as well as sufficient time.*
Additional information can be found on page 96.

87

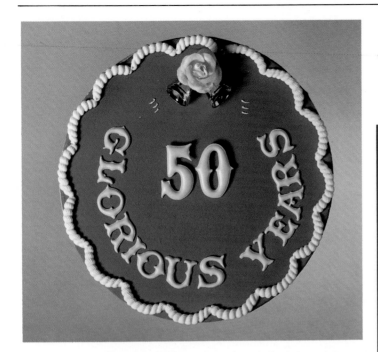

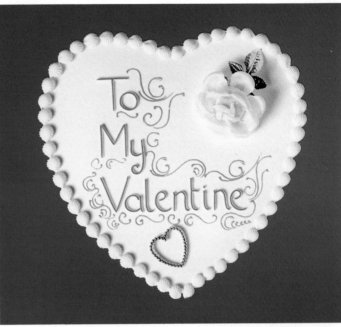

A. A formal "runout" inscription in a style to fit the occasion.

B. A simple message which should go straight to the heart.

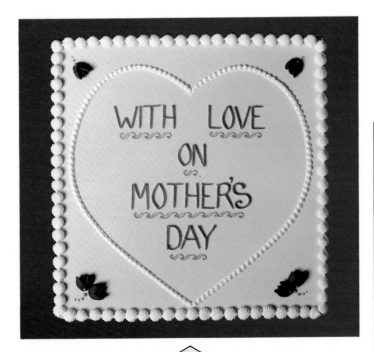

D. The underlining with decorative dot sequences gives a lace edging effect.

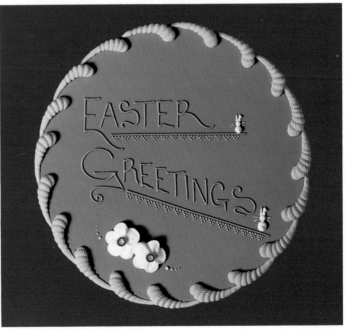

C. A piped heart design on a square cake emphasises the warmth of the message.

Mary Ford's Decorative Cake Tops

NOTE: Before piping the artwork on this page, please study the basic instructions on pages 5 – 14 and ensure that you have the proper equipment and materials, as well as sufficient time.
Additional information can be found on page 96.

A. An example of using matching vertical and horizontal lines and of joining capital letters.

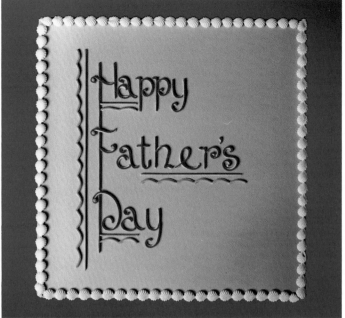

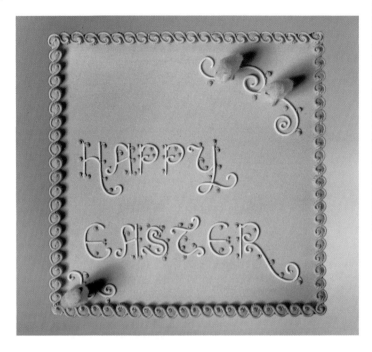

B. Joyful decorated writing aids a happy occasion.

C. Informal positioning of the letters adds to the sparkle of the occasion.

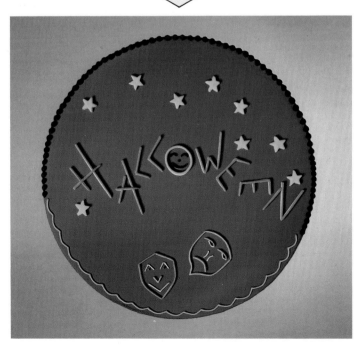

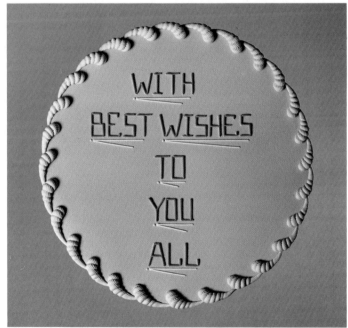

D. A "masculine" cake showing the use of matching colours.

Mary Ford's Decorative Cake Tops

NOTE: Before piping the artwork on this page, please study the basic instructions on pages 5 – 14 and ensure that you have the proper equipment and materials, as well as sufficient time.
Additional information can be found on page 96.

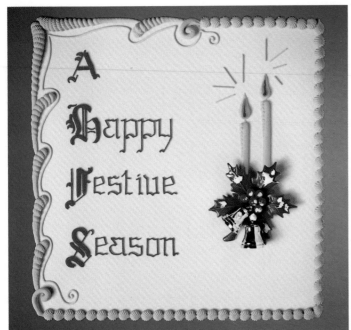

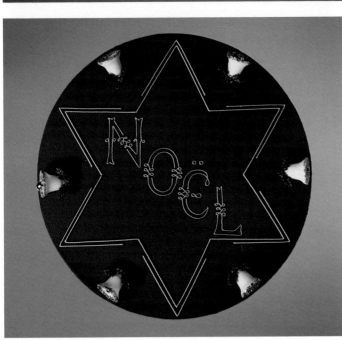

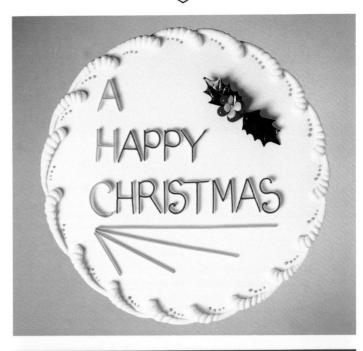

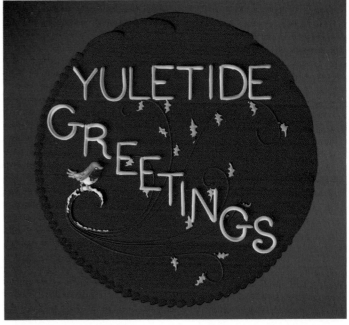

A. A larger piping tube has been used for each capital letter and the decoration is completed with piped candles.

B. A festive cake-top showing the use of two colours in the inscription.

C. Fine piped inscription surrounded by symmetrical lines highlights the stark contrast of the colours.

D. The curved lines on this cake-top form a holly spray over which the seasonal greetings have been piped.

Mary Ford's Decorative Cake Tops

NOTE: Before piping the artwork on this page, please study the basic instructions on pages 5 – 14 and ensure that you have the proper equipment and materials, as well as sufficient time.

Additional information can be found on page 96.

A. Decorative runout letters, ideal for the larger Christmas Cake, can be raised slightly for better effect.

B. A large runout capital letter forms the main decoration of this cake-top.

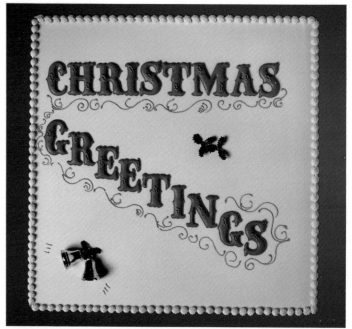

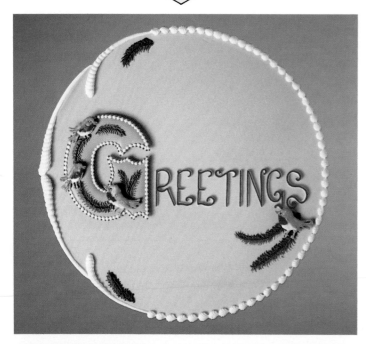

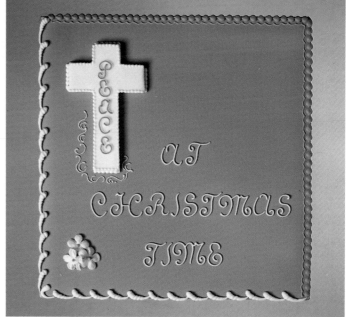

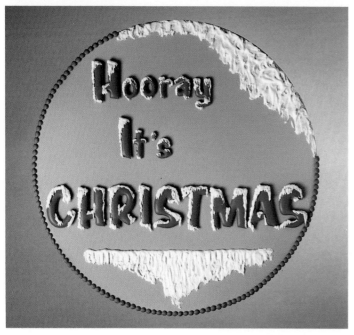

C. An artistically balanced cake for those who really care.

D. This cake-top decoration brings to life the icy winter weather by piping white icing on to the runout inscription.

Mary Ford's Decorative Cake Tops

NOTE: Before piping the artwork on this page, please study the basic instructions on pages 5 – 14 and ensure that you have the proper equipment and materials, as well as sufficient time. Additional information can be found on page 96.

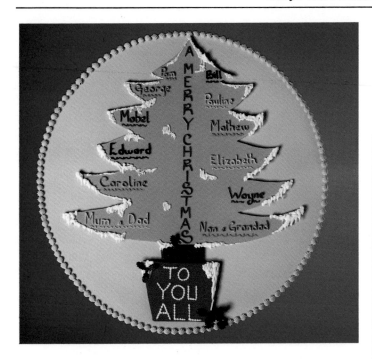

A. This jolly party cake shows a sugar-paste Christmas tree bearing the guests names.

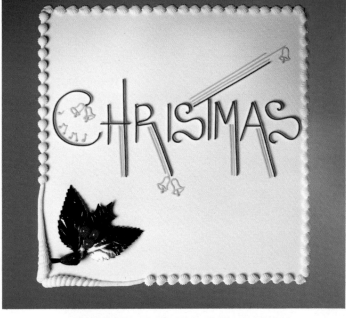

B. The additional piped lines beside the exaggerated letter lines, form the main decoration of this cake.

C. A cake-top showing the effectiveness of simplicity.

D. Father Christmas bringing his message in traditional Christmas style piping.

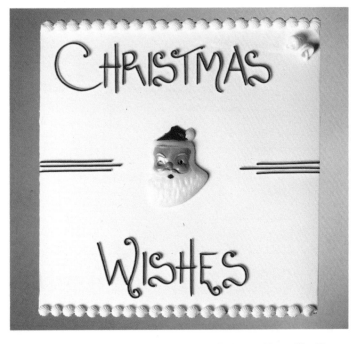

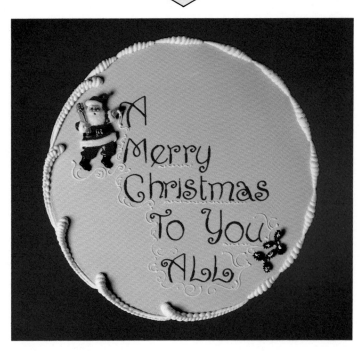

Mary Ford's Decorative Cake Tops

NOTE: Before piping the artwork on this page, please study the basic instructions on pages 5 – 14 and ensure that you have the proper equipment and materials, as well as sufficient time.
Additional information can be found on page 96.

A. A happy but formal greeting using a combination of coloured inscription with tracery.

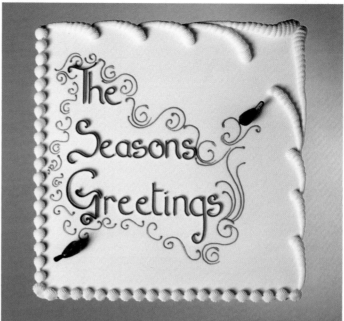

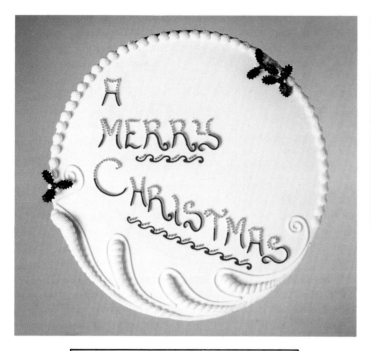

B. Decorative lettering combining piped dots and lines in different colours is the theme of this cake.

C. An open sugar-paste book with a symbolic piped message is the centre-piece of this cake.

D. The piped lettering on the sugar-paste balloons carry their own message as well as the runout plaque.

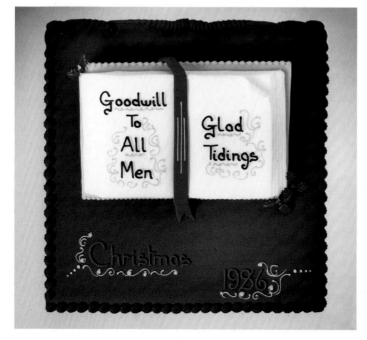

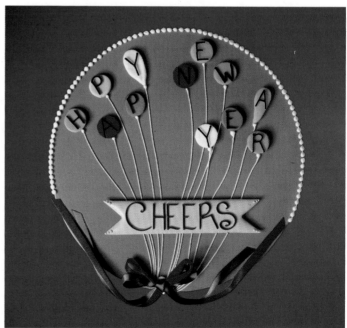

Mary Ford's Decorative Cake Tops

NOTE: Before piping the artwork on this page, please study the basic instructions on pages 5 – 14 and ensure that you have the proper equipment and materials, as well as sufficient time. Additional information can be found on page 96.

Writing Styles Reference

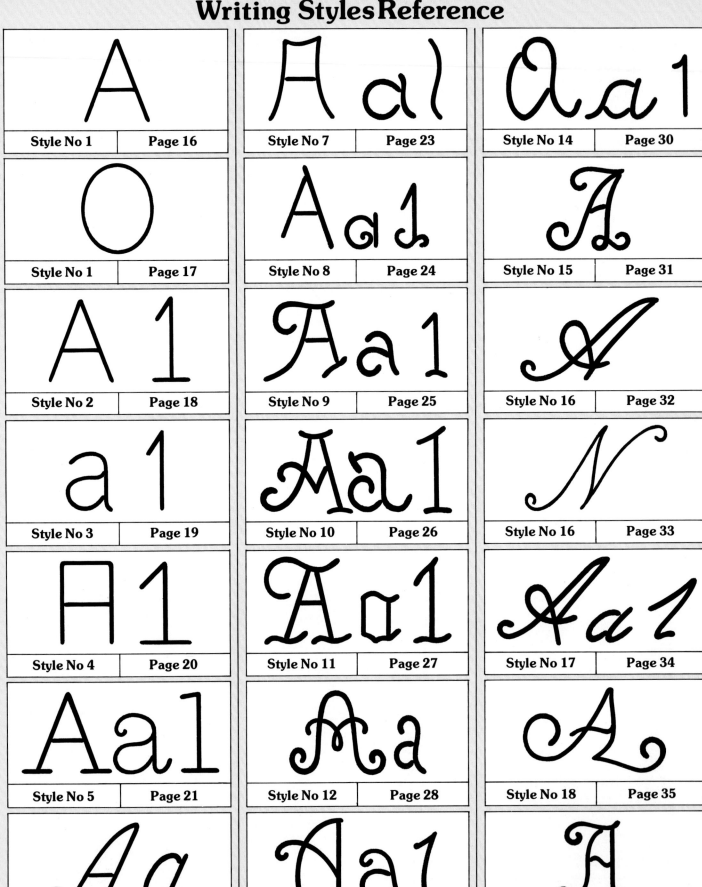

Style No 1	Page 16
Style No 1	Page 17
Style No 2	Page 18
Style No 3	Page 19
Style No 4	Page 20
Style No 5	Page 21
Style No 6	Page 22
Style No 7	Page 23
Style No 8	Page 24
Style No 9	Page 25
Style No 10	Page 26
Style No 11	Page 27
Style No 12	Page 28
Style No 13	Page 29
Style No 14	Page 30
Style No 15	Page 31
Style No 16	Page 32
Style No 16	Page 33
Style No 17	Page 34
Style No 18	Page 35
Style No 19	Page 36

Writing Styles Reference

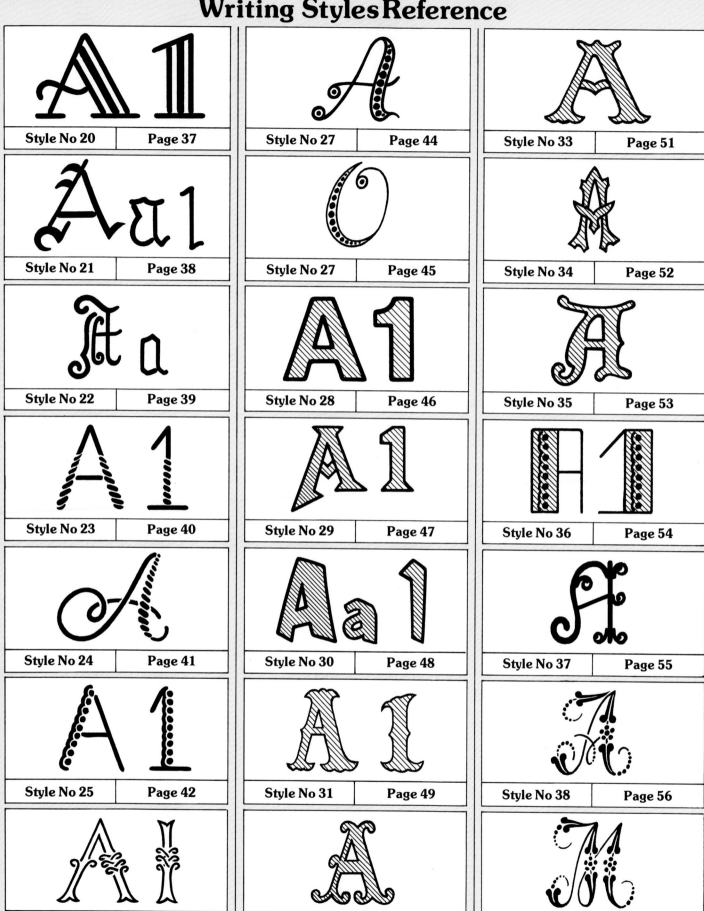

Style No 20	Page 37	Style No 27	Page 44	Style No 33	Page 51
Style No 21	Page 38	Style No 27	Page 45	Style No 34	Page 52
Style No 22	Page 39	Style No 28	Page 46	Style No 35	Page 53
Style No 23	Page 40	Style No 29	Page 47	Style No 36	Page 54
Style No 24	Page 41	Style No 30	Page 48	Style No 37	Page 55
Style No 25	Page 42	Style No 31	Page 49	Style No 38	Page 56
Style No 26	Page 43	Style No 32	Page 50	Style No 38	Page 57

USEFUL HINTS

Royal icing

Ensure royal icing is made the day before use.

Do not use glycerine in royal icing for writing or runouts.

Before filling piping bag, remove a small portion of royal icing from the mixing bowl and smooth out on a clean surface with a palette knife (to remove air bubbles).

It is better to use a small greaseproof paper piping bag with a piping tube, although a half-filled piping pump (syringe) can be used.

The cake coating must be dry before attempting to pipe the message.

Royal icing writing can be piped directly on to royal icing, sugar paste, marzipan, chocolate and fondant dried surfaces.

Working conditions

Ensure cake is at a comfortable working height when either sitting or standing.

Always work in a dry warm atmosphere.

Design and practice work before piping on to cake.

Tracing figures

To protect the book's pages and to hold the greaseproof paper secure whilst tracing, fold the greaseproof paper over the top edge of the page (by about one inch) and secure with two paper clips.

Coloured icing

Use colour to suit occasion.

Ensure the colour to be used makes the inscription stand out (although remember the first piping should colour-match the cake coating).

The inscription

As the inscription or message is the first thing to be noticed by the cake's recipient, ensure the writing is neat and clear and has eye appeal.

American Terms

English	American
colouring	food colors
greaseproof paper	parchment paper
icing	frosting
icing bag	frosting cone – decorating cone
icing sugar	confectioner's sugar
icing tube	nozzle, tip
marzipan	almond paste
palette knife	spatula
turntable	turntable – lazy Susan

ABBREVIATIONS
kg	–	kilogram
g	–	grams
lbs	–	pounds
oz	–	ounces
ml	–	millilitre
pt	–	pint

GLOSSARY & INDEX